IMAGES
of America

PORTLAND'S
MULTNOMAH VILLAGE

D0817277

IMAGES
of America

PORTLAND'S
MULTNOMAH VILLAGE

Nanci Hamilton

ARCADIA
PUBLISHING

Copyright © 2007 by Nanci Hamilton
ISBN 978-0-7385-4890-6

Published by Arcadia Publishing
Charleston SC, Chicago IL, Portsmouth NH, San Francisco CA

Printed in the United States of America

Library of Congress Catalog Card Number: 2006941038

For all general information contact Arcadia Publishing at:
Telephone 843-853-2070
Fax 843-853-0044
E-mail sales@arcadiapublishing.com
For customer service and orders:
Toll-Free 1-888-313-2665

Visit us on the Internet at www.arcadiapublishing.com

*To my father, Daniel Joseph Leech; my son, AJ Reel; and
my grandson, Colby Porter Reel*

CONTENTS

ACKNOWLEDGMENTS

Without the help of many others interested in and dedicated to preserving the history of this community, this book would not have been possible. The assistance of the Multnomah Historical Society was vital and their contribution invaluable. The purpose of the Multnomah Historical Association, founded in 1979, is to collect, preserve, exhibit, and publish material of a historical character and foster community-wide interest in the growth and development of the southwest neighborhoods of Portland, Oregon. This book could not have been created without their hard work, love of local history, and their permission to reproduce images from their collection. Special thanks to historian Lowell Swanson, who paved the way for this book through his research, writing, and contributions to preserving local history; and Kaye Synoground, Susan Keller, and Patti Waitman-Ingelbretson for their help and collective knowledge.

Many thanks also to Diana Banning, archivist at the City of Portland Stanley Parr Archives and Record Center; Don Porth of Portland Fire and Rescue; Art Bush, junior grand warden of the Tigard Orenomah Lodge 207 of the Ancient Free and Accepted Masons; Joan Wall, who made key introductions; Bill Raz, who generously shared his family photographs and many delightful memories of growing up "in the country" and attending Multnomah School; Betty Russell Meisner, who generously shared her photographs and memories of growing up in Multnomah; Brian Johnson; Jim and Kathy Hill, antique dealers in Multnomah for 29 years; Tom Klutz and Tricia Knoll of the Portland Water Bureau; and Bob McGown. My heartfelt thanks also to the many others who helped, too numerous to name.

I also wish to thank my editor at Arcadia Publishing, Julie Albright, for her gracious assistance, guidance, and support.

While I have taken great care to ensure that details and facts in this book are correct, oversights and mistakes happen. I humbly apologize for any errors; they are the fault of this author and not of the wonderful people who were kind enough to help me.

Photographs without other attribution are from my personal collection.

INTRODUCTION

Today when people in Portland refer to Multnomah Village, they generally mean a small, pedestrian-friendly knot of shops and restaurants that lie in a triangular space formed by the oblique intersection of SW Multnomah Boulevard and SW Capitol Highway, with the wide end of the triangle being SW Thirty-first Avenue. Multnomah Boulevard is relatively broad and ramrod straight. Capitol Highway, on the other hand, meanders its way to and from their intersection—which is not really an intersection at all, since Capitol Highway crosses Multnomah Boulevard via a gracefully arched and curved overpass. I have long been curious about why these two thoroughfares have such marked differences in character and construction, and the stories behind this unusual configuration.

The short answer is that Multnomah, which was once a densely forested area of mostly fir, cedar, and maple trees covering the hills and ravines around the Fanno Creek watershed, was shaped by the railroad. When and why the railroad came (and went) as it did, and what impact it had on the personal, commercial, residential, and environmental aspects of the community require a longer answer.

The long, straight stretch of SW Multnomah Boulevard is the path the train took. Its level linear path was briskly engineered in 1907–1908 by the likes of men who had carved a route through the Rocky Mountains and would move on to make railroad pathways elsewhere. Making a straight, level path through the terrain of southwest Portland was not without challenges but was something these men and their machines could dispassionately handle, building up earth up here, moving it out of the way there, to create an efficient beeline between two points.

SW Capitol Highway, on the other hand, no less of an engineering feat, resulted from an entirely different road-building effort. Early residents of the area were self-reliant in the strictest sense, being utterly responsible for their own well being and prosperity. Road building, which in and of itself puts no food on the table, creates no shelter from inhospitable weather, and clothes no one, was an enterprise pioneers would only undertake as a means to profoundly important ends. What is now Capitol Highway was constructed and improved as time, labor, and materials were available, based on pressing local needs and eminently practical assessments of the advantages and disadvantages presented by the local terrain. It developed segment by segment beginning in the early 1850s. Starting as Slavin Road in Hillsdale, it passed through the place later named Multnomah on its way to Taylors Ferry Road. Taylor's Ferry, named for John H. Taylor, was a barge Taylor built to cross the Tualatin River, a service for which he collected tolls and from which he handsomely profited for many years.

Multnomah as a distinctly named place did not exist until 1907. It received its name when the planners of the Oregon Electric Railway, having determined the route that their train would take to connect Portland to Salem, decided to locate a station near the place where their tracks would cross Capitol Highway. They assigned the name Multnomah, associated with an important Oregon Native American chief and tribe, to this station.

Before the railroad, the area was an undifferentiated tract between Hillsdale and West Portland Place. Scattered residents in the 1880s and 1890s were mainly dairy farmers, most of Swiss-German origin, with some of the earliest being the Raz, Tannler, and Gabriel families. The opening of the transcontinental railroad connection to Portland in 1883 made it possible to reach Portland from the East Coast by train, and between 1883 and 1891, the population in and around Portland doubled. Farmers seeking land were attracted to the west side of the Willamette River because

more open land close to the city was available than on the east side. The Hillsdale area, which connected to Portland by means of Slavin Road, was both accessible to settlers and provided a means by which they could sell their products to Portland city residents.

The coming of the railroad in 1908 catalyzed the development of the Multnomah neighborhood. Along with relatively inexpensive transportation for commuting to jobs in the city, the area's rural character and low real estate prices made its location ideal for families longing for their own affordable homes and gardens. Real estate developers advertised and platted new streets. Merchants established businesses to serve the needs of the small community, beginning with some small general stores and a lumber company. Less than five years after the station was established, the little town had a school and a post office. Within seven years, electricity, telephone service, and gas lines were available—attractions which increased population growth. Access to clean and reliable piped-in water also started to become available to parts of Multnomah, replacing the earlier hand-dug wells.

The automobile's impact on the community became unmistakable around the time of the First World War. Capitol Highway was paved in 1915 with poured concrete, and the highway became as important to the growth of the community as the railroad had been. By 1919, a gas station and a garage had been established. By the 1920s, most businesses were located on Capitol Highway, a block up the hill from the railroad depot. In 1924, the new school building and Masonic Lodge were built on the highway. Some of the older frame structures facing the highway, such as the Lovejoy store, the Ellis drugstore, and the log building across the street from them, were torn down and replaced with sturdier, more modern buildings—facades that are familiar to visitors today. The increase in automobile traffic drove the railway's decision in 1927 to construct an overpass for Capitol Highway over their tracks, their concern being to prevent collisions between trains and automobiles.

Multnomah's "golden age" ended with the Great Depression. The bank, established in 1923, was forced to close in 1934. Though all depositors got their money back eventually, confidence was shaken. The railroad ceased to offer passenger service in 1933, though freight was carried for a few more years. World War II cast a pall for nearly two years before Pearl Harbor forced the U.S. to enter the war; many families in the area had members serving in the war, and stateside rationing and defense exercises touched everyone.

The most profound period of change in Multnomah, however, occurred after World War II ended. In the 1930s, the old Southern Pacific Railroad tracks southeast of Multnomah were removed and SW Barbur Boulevard was built on the old right-of-way. The rise of chain stores along Barbur, such as Fred Meyer, and shopping malls in the area, such as Washington Square in Tigard, eroded the clientele that merchants in Multnomah relied upon. Over the next few years, many longtime Multnomah merchants closed their doors for the last time. Only a handful of businesses from before 1940 remain in the village today—notably John's Marketplace, the descendant of John's Meat Market (1923), and Renner's Grill (1939).

Portland annexed Multnomah in pieces during the 1950s, the advantages being that the larger entity could more easily fund and provide services such as sewers and police protection, but this change was also viewed as another loss by many. As the Multnomah commercial district languished, locals feared the decline was permanent. By 1969, eleven storefronts on the main two blocks along Capitol Highway were vacant. The Multnomah School closed in June 1979. In the 1970s, however, antiques businesses began moving into the area thanks to reasonable rents and began the revitalization of the vicinity.

Multnomah, now generally called Multnomah Village (a subject on which many longtime residents have an opinion), has proved to be resilient and practical—traits in line with its past. As the village prepares to enter its second hundred years, the commercial area is vibrant and eclectic. Its character, intimacy, and vintage verve are authentic without being cloying. The surrounding neighborhood contains many older houses in close proximity with recently built homes, on quiet, tree-lined streets, an easy blend of the old and new. This book gives readers a glimpse of what makes this place unique and special, qualities that the neighborhood retains despite change.

One

EARLY MULTNOMAH VILLAGE HISTORY
1850–1906

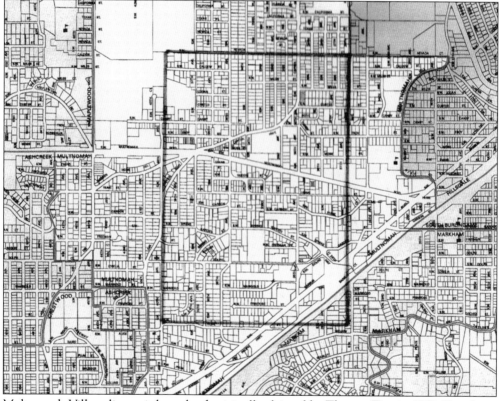

Multnomah Village lies mainly on land originally claimed by Thomas Tice in 1852. Tice, born in Ohio about 1815, came from Missouri to Oregon with his wife, Mary Ann (Polly), and three children in October 1850. In 1852, the couple claimed a 640-acre tract (320 acres each) that included what is today the heart of Multnomah Village. This map shows the boundaries of the Tice claim superimposed on contemporary map of the village and surrounding neighborhoods. Between 1852 and 1858, Polly conveyed half of her half (160 acres) to Thomas. In 1858, Thomas and Polly divorced, and shortly thereafter, Polly remarried and sold her 160 acres to Finice Caruthers, an active Portland land speculator. Finice died in 1860, at age 41, childless and without a will or heir, occasioning a series of convoluted and expensive legal skirmishes that eventually ended in an estate auction of his property holdings. (Map from the City of Portland, Office of Neighborhood Involvement and Bureau of Planning.)

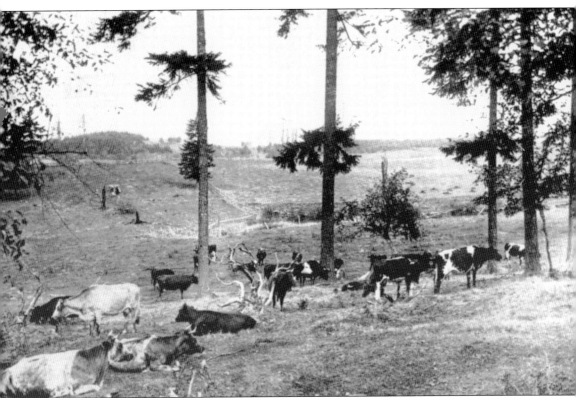

In the heavily forested rolling hills south and west of Portland, dairy farming was a logical choice for the early settlers. Having felled trees for lumber to build fences, dairy cattle could graze in the stump-filled cleared areas, productively using the land until owners had the time and resources to remove the stumps and create open fields. Stump clearing was an arduous process, requiring horses, handsaws, and dynamite, and was impossible in rainy, muddy weather. The holes that the stumps left behind were filled with large earth-moving scoops drawn by horses. (Courtesy of the Multnomah Historical Association.)

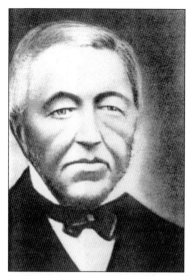

In the 19th century, the hillsides of southwest Portland were dotted with dairies largely operated by Swiss immigrants. Several of these pioneer dairymen were children of John Raz (1817–1881) and Anna Frutiger Raz (1825–1900) of Innertkirchen in Canton Bern, Switzerland. To earn money to pay off family debt, two unmarried sons, Melchior and John, left Switzerland in 1885 and settled in Hillsdale. They established their own dairy—first called the Raz Brothers Dairy, later the Fulton Park Dairy—on a 93-acre tract. In 1887, Anna emigrated to join her sons, accompanied by her youngest son, Henry, and three unmarried daughters. Eventually, all of Anna's remaining children and their families emigrated from Switzerland to Oregon. (Left, courtesy of the Multnomah Historical Association; right, courtesy of Bill Raz.)

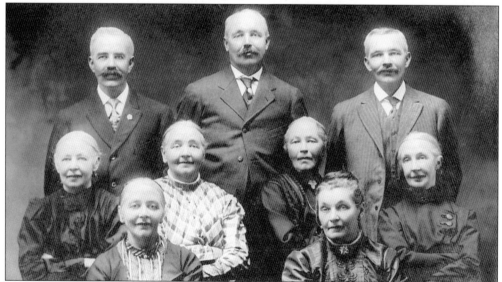

Ten children of John and Anna Raz emigrated from Switzerland to Oregon in the 1880s and 1890s. In the photograph (taken sometime between 1904 and 1920) are, from left to right, (first row) Elizabeth Fuhrer and Barbara Neiger; (second row) Magdalena (Mattie) Roth, Katharina Schlappi, Margareta Schild, and Anna Raz; (third row) Henry Raz, Melchior (Mike) Raz, and John Raz. Kaspar Raz, the oldest brother, also emigrated but died in 1904 and therefore was not included in the picture. (Courtesy of Bill Raz.)

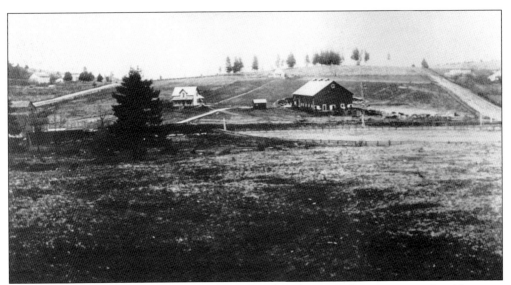

Until the early 1900s, the area remained mainly a densely wooded area, unnamed and home to only a few residents. Settlers in nearby Hillsdale had much to do with settling and clearing what developed into Multnomah, which was not yet differentiated from Hillsdale. This view of Hillsdale was taken in 1903 from a vantage point now in Multnomah looking east to the Fulton Park Dairy, owned by the Raz brothers. In the center is the current site of the Mary Rieke Elementary School. The house at the top of the hill in the center background is the Kaspar Raz home (current site of Woodrow Wilson High School). Slavin Road (now called Capitol Highway) is on the left (current site of the Hillsdale commercial district), and Hoffman Road (which is now SW Vermont Street) is on the right. The tracks of the Southern Pacific Railroad are below the dairy (now Bertha Boulevard). (Courtesy of the Multnomah Historical Association.)

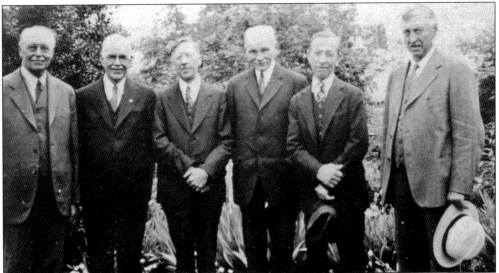

The Multnomah Village area was, at one time, home to more than a dozen dairy farms. This photograph, taken about 1946, shows, from left to right, Melchior Raz, Henry Raz, Rev. John Egger (pastor of the Hillsdale Community Church), John Raz, Melchior Fruitiger, and Henry Tannler—all except Egger being Swiss-German emigrants with dairy interests in the Hillsdale and Multnomah area. (Courtesy of the Multnomah Historical Association.)

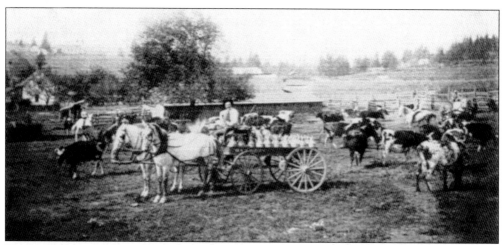

This view shows the Raz milk ranch about 1903. In 1902, they built a large, new barn and a 10-room house at SW Eighteenth Avenue and SW Vermont Street. The buildings in the left background of this view are the Hillsdale School and Mount Olive Presbyterian Church (which since the 1950s has been the location of St. Barnabas Episcopal Church). The Raz family donated property for the school and church. (Courtesy of the Multnomah Historical Association.)

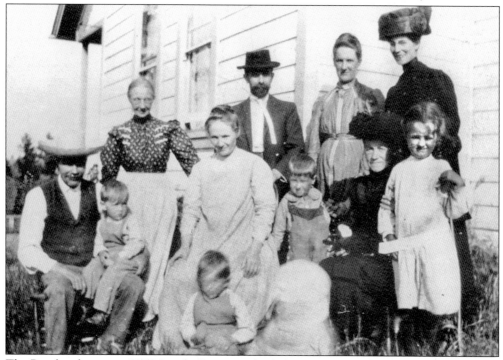

The Raz farmhouse on SW Nevada Court was built for Anna Raz, who never married, by her brothers. This 1911 image taken at the back of the house captures, from left to right, (first row) John B. Raz (son of John Raz); (second row) John Raz holding his son Stephen Henry Raz, Katrina (John's wife), Werner Raz (son of Melchior and Marie Raz), unidentified, and Wilhelmina Raz (daughter of Melchior and Marie Raz); (third row) Anna Raz, two unidentified people, and probably Marie Wilhelm Raz (Melchior Raz's first wife). All of these families were in the dairy business. (Courtesy of Bill Raz.)

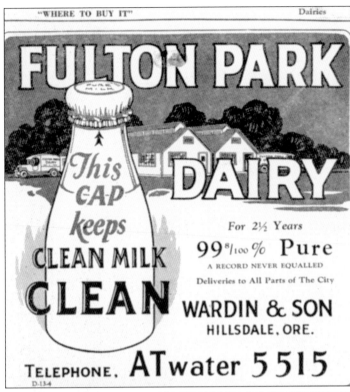

The Fulton Park Dairy, under Wardin ownership, was one of a handful of dairies with a display ad in the August 1929 Pacific Telephone and Telegraph Company Telephone Directory. In 1908, the Raz brothers sold the Fulton Park Dairy to Wardin and Heusser, later known as Wardin and Son. Elizabeth Raz, daughter of Kaspar Raz, had married Gustav F. Wardin in 1901. In 1951, the Wardins sold their dairy to Alpenrose Dairy. In 1949 and in 1953, the School District of Multnomah County purchased land from Warden and Son. Wilson High and Mary Rieke Elementary Schools were erected on the property.

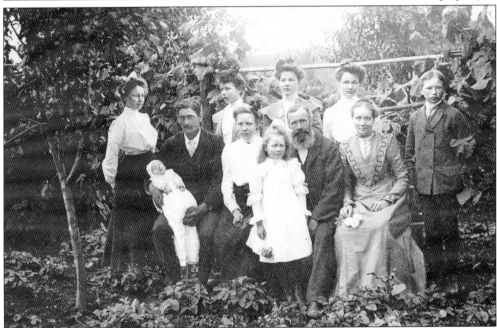

This image of the Wardin family dates from about 1900, probably taken in the garden of the farmhouse for the Fulton Park Dairy. Behind the group is a grape arbor, and to the left is an apple or pear tree. The bearded gentleman in the front row might be Kaspar Raz, the older brother of 1885 emigrants John and Melchior Raz. Kasper emigrated sometime after 1887. (Courtesy of Bill Raz.)

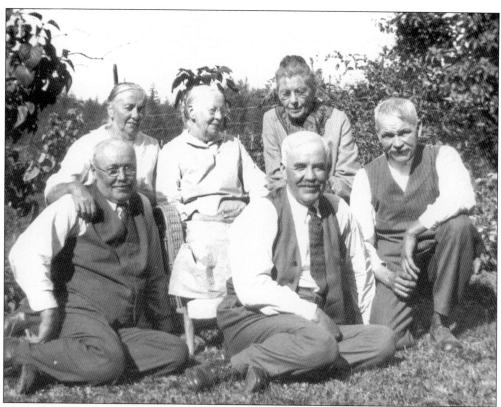

This 1940s image taken on one of the Raz farms shows six of the emigrant Raz siblings, from left to right, (first row) Melchior Raz, Henry Raz, and John Raz; (second row) Elizabeth Fuhrer, Magdalena Roth, and Barbara Neiger. (Courtesy of Bill Raz.)

This photograph was taken in front of John Raz's farmhouse about 1944. From left to right are Melchior (Mike) Raz, Henry Raz, possibly Katrina Tannler Raz (although not positively identified), and John Raz. (Courtesy of Bill Raz.)

Taken about 1900, this view shows the Multnomah Dairy Farm owned by Henry and Anna Tannler. The road is Hoffman Road (now SW Vermont Street), named for another Swiss emigrant and dairyman, John P. Hoffman. Hoffman built the road with the help of hired Chinese laborers so he could haul milk from his dairy (at what is now SW Fifty-fifth Avenue and SW Vermont Street) up to Hillsdale and then down to Portland. The house still stands at 4002 SW Vermont Street. The buildings to the northeast are the Frutiger Dairy buildings at SW Forty-fifth Avenue and SW Vermont Street. (Courtesy of the Multnomah Historical Association.)

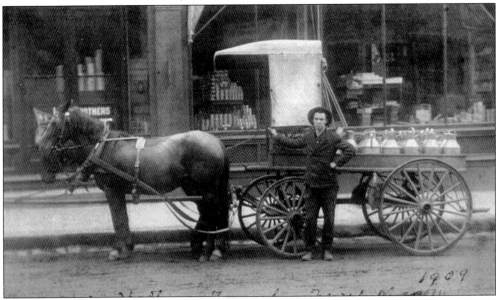

The Tannler family owned and operated the Multnomah Dairy farm at SW Fortieth Street and SW Vermont Avenue. In this 1909 picture, Bill Hallam, driver, stands beside a Multnomah Dairy Farm milk wagon loaded with three-gallon milk cans for delivery in Portland. Milk was delivered seven days a week. The driver carried a tin measure marked in one-pint, one-quart, and two-quart capacities, and the customer provided a container for the milk. (Courtesy of the Multnomah Historical Association.)

Henry Tannler (1874–1946), son of John and Marianne Tannler, married Annie Stricker (1887–1968) on March 19, 1908. Henry was the first of the Tannler family to emigrate from Switzerland to Oregon; in 1887, he paid to have his parents and four sisters leave Switzerland to join him. Annie was the daughter of Herman Struecker (a name later Americanized to Stricker) and his wife, Hannah Jaeger. (Courtesy of the Multnomah Historical Association.)

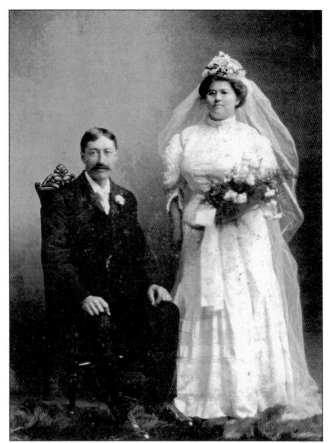

This view shows Annie and Henry Tannler standing on the front porch of their farmhouse on Hoffman Road around 1910. (Courtesy of the Multnomah Historical Association.)

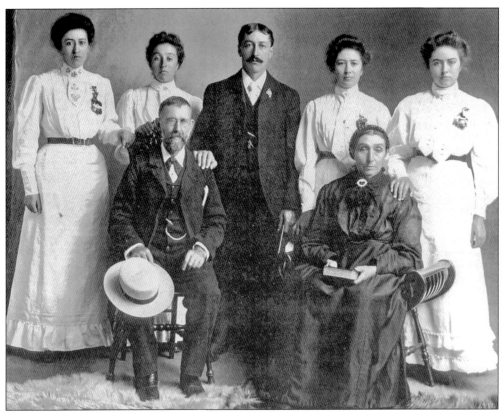

By 1908, the entire Tannler family was in Oregon. This photograph, most likely taken on Henry's wedding day, shows, from left to right, (first row) John and Marianna Tannler; (second row) Annie Zweifel, Elsie Blaser, Henry Tannler, Katie Ernst, and Margaretha Rychen—all children of John and Marianna. (Courtesy of the Multnomah Historical Association.)

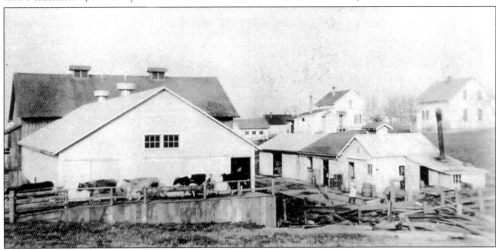

In this view of the Tannlers' Multnomah Dairy Farm, taken in the late 1920s before the Great Depression, the milking barn and various sheds are seen in the foreground. The farmhouse is on the right in the background a little higher up the hill. (Courtesy of the Multnomah Historical Association.)

The Silver Hill Dairy, operated by Henry Frutiger, advertised in the August 1929 Pacific Telephone and Telegraph Company Telephone Directory. Located at the present site of the Mittelman Jewish Community Center, the land was leased from the Raz family.

For HIGH GRADE

RAW MILK and CREAM

Call

BRdway 9827-R-4

We deliver West and East Side

SILVER HILL DAIRY

H. Frutiger, Prop.

D-21-1

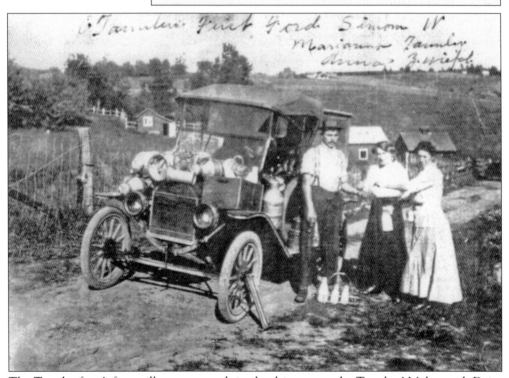

The Tannler farm's first milk wagon stands in the driveway to the Tannlers' Multnomah Dairy farm. From left to right are Simon and Marianna Tannler and Anna Zweifel. (Courtesy of the Multnomah Historical Association.)

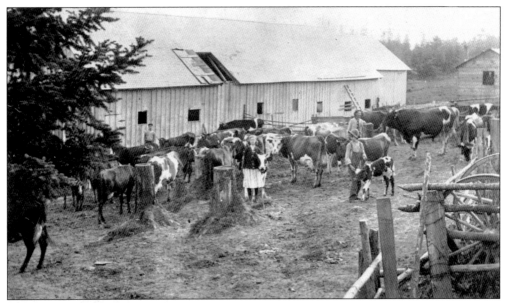

The Denley family purchased a tract of land within the boundaries of the original Tice donation land claim on the west side of Capitol Highway in 1907. In this 1913 view of the Denley family dairy barn and milking herd, owner John Denley stands in the back right, holding a tether rope for the bull. Also pictured are, from left to right, his son Will, daughter Florence, and their cousin John Denley. The Denley herd was comprised of more than 100 cows. (Courtesy of the Oregon Historical Society Research Library, OrHi 73932.)

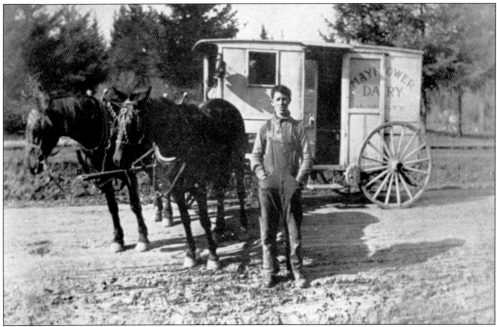

Will Denley, age 16, son of dairyman John Denley and his wife, Jennie, stands with the family's Mayflower Dairy team and delivery wagon used to deliver milk daily to customers in Portland. The photograph was taken in front of the Denley residence on Slavin Road (later Capitol Highway) around 1909. (Courtesy of the Oregon Historical Society Research Library, OrHi 68066.)

Ulrich Gabriel, born in Switzerland in 1871, came to the area about 1890. His mother was from the Cadonau family, and so he likely had relatives in this area. He married another Swiss emigrant, Katherine (Katie) Amacher, in 1898, and they had two daughters, Anna Magdalena and Margaret. Katie died in 1904 when she was only 33, leaving him with two young daughters to raise. Katie's sister Anna became Ulrich's second wife. Ulrich, Anna (top), Margaret (bottom), and Anna Amacher Gabriel are seen in this 1908 photograph. Ulrich bought and farmed property south of Hoffman Road (now SW Vermont Street) and operated the Pine Creek Dairy. He raised corn, wheat, oats, clover, and potatoes, but his main source of income was his dairy herd of 75 to 80 cows. (Courtesy of the Multnomah Historical Association.)

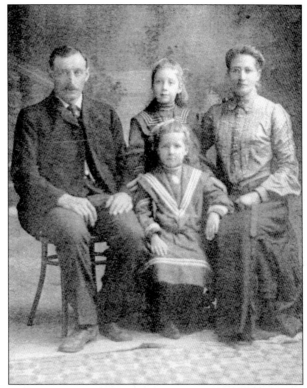

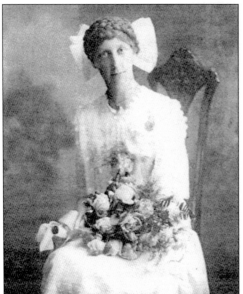 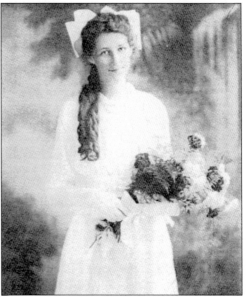

These portraits of Anna (left) and Margaret Gabriel (right) were probably taken around 1923. Anna married Swiss emigrant Johann (John) Feuz on June 20, 1923. Shortly before their marriage, John purchased a meat market in Multnomah from James Sullivan. John's Market and Grocery was in business in Multnomah for more than 45 years. Margaret Gabriel did not marry and worked with Anna and John Feuz at John's Market for many years. (Courtesy of the Multnomah Historical Association.)

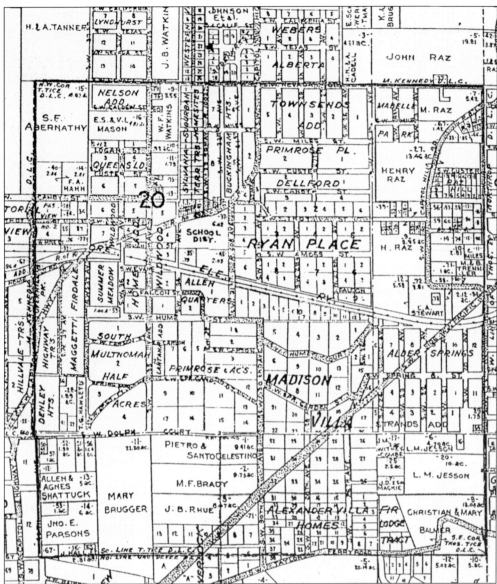

D. K. Abrams and others platted the Multnomah area in 1883. In 1902, it was replatted by C. B. Woodworth; this replatting eliminated many of the original street names and replaced them. Since that time, numerous additions have been made. In 1935, Portland made a citywide shift to rationalize street names and make finding locations easier—of importance as the population became more mobile—which again changed most of the street names and house numbers in Multnomah. This 1936 map shows the locations of the early plats of importance in Multnomah and the names of some of the landowners with the new street names. The original Tice claim is outlined. The Home Addition includes most of the commercial district. Ryan Place is to the east, and Primrose Acres is to the south. Among the people who arrived soon after the replatting of Multnomah were the Goldthwaites (1911), Chester Ehle and Joe Simon (1913), A. H. Hahn, James Ireland, Henry Webster, William Smith, Tom Hawley, George McBride, Archie Parker, James Ryan, Earl Kessler, W. P. Stacks, Paul Whitesides, and many others. (Courtesy of the Multnomah Historical Association.)

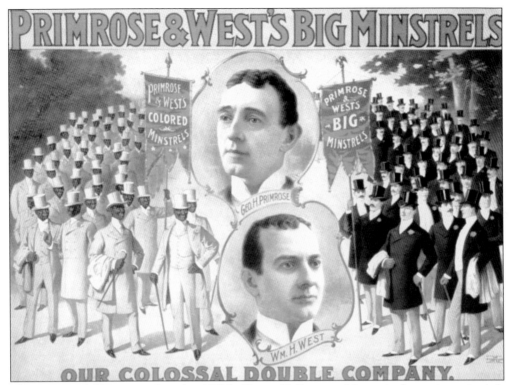

The Primrose Addition was platted in 1919 by George H. Primrose (shown in the top inset picture), the head of the famous Primrose Minstrels. Within the addition's boundaries is the highest point of land within the immediate area, having a clear view of the commercial center of Multnomah. Primrose purchased the land intending to make it a haven for his stage people when they retired; however, only one person ever settled in Multnomah: Ned Burke, who worked with Primrose for 27 years. He sold real estate in the Multnomah area, and his talent as an entertainer was greatly appreciated by local residents.

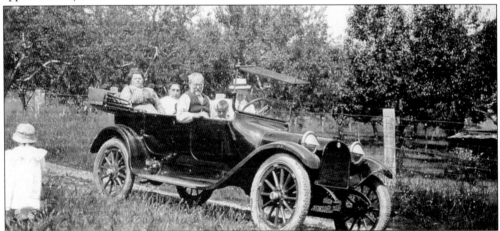

Marianna Tannler, her daughter-in-law Annie Tannler, husband John Tannler, grandson Walter Blaser, and son Henry Tannler are pictured here in the Tannlers' first car, a Dodge, purchased around 1926. A daughter of Andrew Naegeli is to the left. The car is on what is presently SW Vermont Street. Note the orchard in background. (Courtesy of the Multnomah Historical Association.)

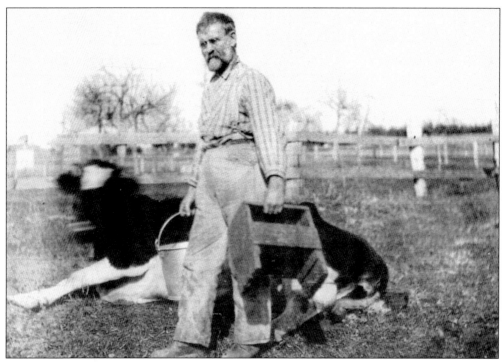

In this 1904 photograph, John Tannler (1844–1925), carrying a milk pail and a low stool, is getting ready to milk the cows. (Courtesy of the Multnomah Historical Association.)

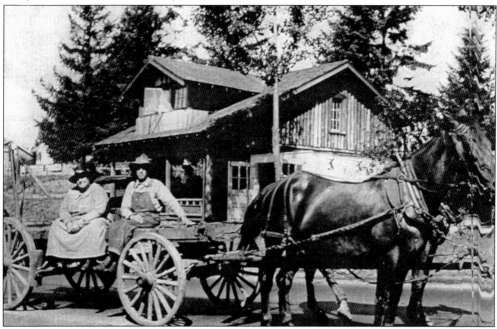

George and Irene Fetrow came into Multnomah in a horse-drawn wagon about 1914. The Fetrows moved to Oregon from Indiana about 1911 with children George, Blanche, Dorothy, and Thelma. The log building in the background stood on the northeast corner of SW Thirty-fifth Avenue and SW Capitol Highway. (Courtesy of the Multnomah Historical Association.)

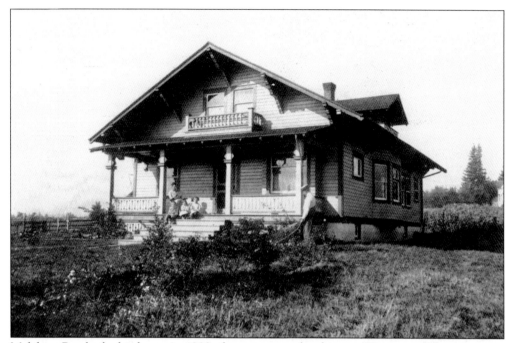

Melchior Raz built this home in 1908, the same year that his son Werner was born. At some point, it was moved a short distance to its present location at 2335 SW Caldew Street. The home is still owned and occupied by members of the Raz family. (Courtesy of the Multnomah Historical Association.)

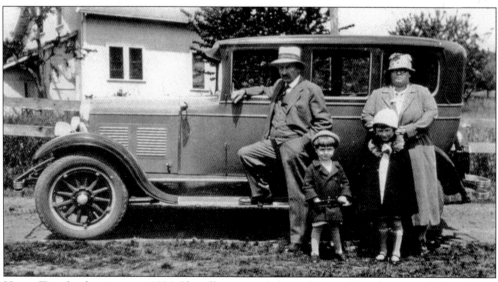

Henry Tannler, leaning on a 1926 Chandler automobile, and Annie Tannler stopped for a picture in 1928 with their cousin's children, John and Margaret Bucher. (Courtesy of the Multnomah Historical Association.)

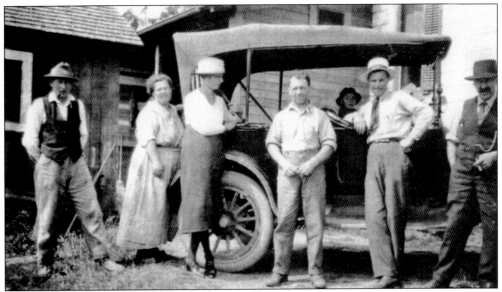

The Tannlers' next car was a Ford. In this *c.* 1930 photograph, taken at the Tannler farm are, from left to right, Mike Schlappi, Anna Tannler, Rose Roth, F. Rychen, A. Jaggi, and Henry Tannler. Walter Blaser is in the car. Annie and Henry Tannler did not have children of their own but raised their nephews and niece—Walter, Bertha, and Arnold Blaser. Bertha Blaser later married Paul Raz, son of Henry and Susette Raz. (Courtesy of the Multnomah Historical Association.)

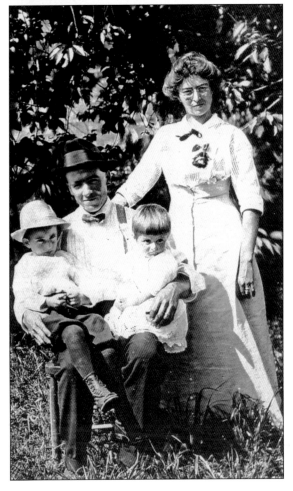

John and Margartha Tannler Rychen are pictured with two of their nephews at a family gathering around 1930 at the Tannler farm. Johnny Zweifel sits on John's right knee, and Walter Blaser is on the left. (Courtesy of the Multnomah Historical Association.)

This *c.* 1930 photograph shows grandfather John Tannler holding his grandson Johnny Zweifel, son of Annie Tannler Zweifel. (Courtesy of the Multnomah Historical Association.)

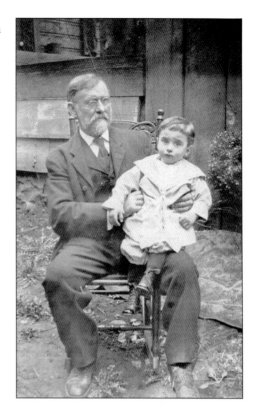

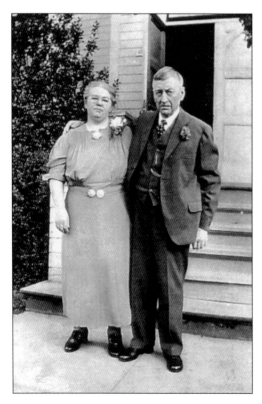

Henry and Annie Tannler celebrated their 31st wedding anniversary on March 19, 1939. Henry and Annie's farm was located on the property now occupied by Gabriel Park. (Courtesy of the Multnomah Historical Association.)

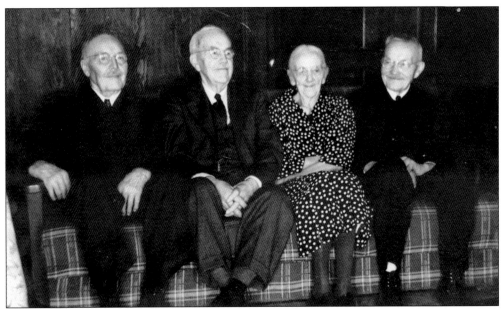

This 1940s image shows, from left to right, Melchior (Mike) Raz, Henry Raz, Elizabeth (Elsie) Fuhrer, and John Raz. (Courtesy of Bill Raz.)

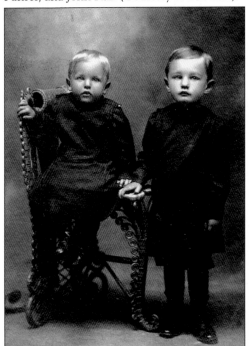 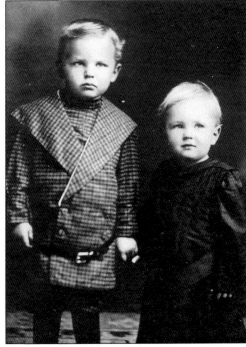

John Raz had three sons—John B. Raz, Stephen Henry Raz, and Melchior Raz. These images of the two older boys were taken about 1910 and 1911. Both boys attended Benson High School. For a while, they commuted to school on the Red Electric Railroad from Hillsdale. In 1917, their father bought a Model T Ford; however, he never learned to drive, so the boys were the drivers (at ages 11 and 9 in 1917). Later they used the Ford to get back and forth from school. (Courtesy of Bill Raz.)

This treasured family photograph of John B. Raz milking his favorite cow, a Jersey named Rosie, was taken in the 1980s in the milking barn of his farm, which occupied the location where the Greater Portland Bible Church now stands. He was born in 1906 in a farmhouse on the same property, the son of Swiss emigrants John Raz and Katharina Tannler, who married in Oregon. A hardworking man, John B. Raz farmed most of his life and worked as a carpenter and building contractor. As a young man, John worked with a team of horses to dig basements for the construction of some of the new houses that were springing up in the area. His younger brother, Stephen Henry Raz, founded Raz Transportation. (Courtesy of Bill Raz.)

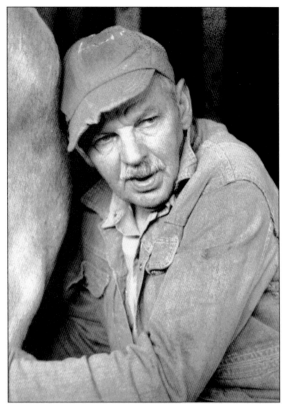

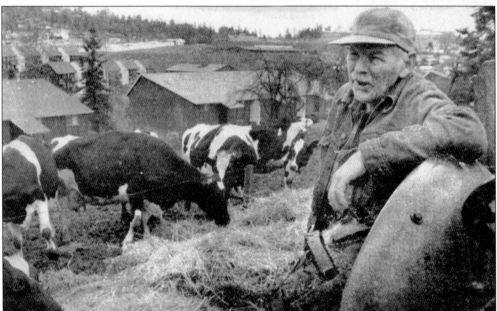

This photograph of John B. Raz was taken on his farm about 1983 and appeared in the *Oregonian*. John was the owner of what he described as the "last working dairy farm within the Portland city limits" and was a farmer and a carpenter most of his life. He died in 2005 at age 98. (Courtesy of the Multnomah Historical Association.)

Established in 1851, the Greenwood Hills Cemetery at the intersection of SW Palatine Hill Road and SW Boones Ferry Road is the final resting place for many members of the earliest families that settled in the Multnomah area and played a part in the growth and development of the village.

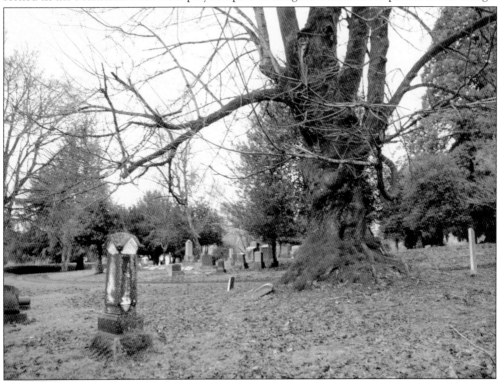

Members of the Frutiger, Gabriel, Hoffman, Nageli, Raz, Tannler, and Wardin families are among the graves in the Greenwood Hills Cemetery. This view shows one of the very old oak trees under which members of the Raz family are buried.

Two

THE OREGON ELECTRIC RAILROAD COMES TO THE VILLAGE
1907–1914

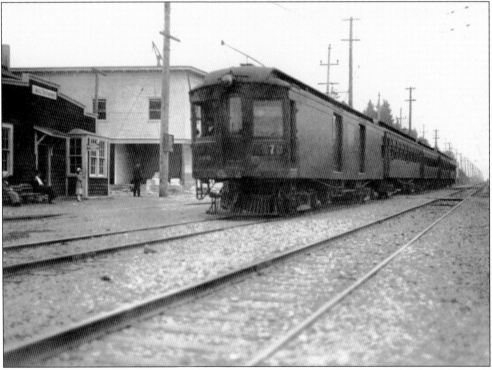

The Multnomah Village neighborhood got its name from the Oregon Electric Railroad's Multnomah Station, built in 1907 at 3535 SW Multnomah Boulevard, across from what is now Marco's Café and Espresso Bar. Trains ran from Portland to Salem and through this area ran along Multnomah Boulevard. This photograph captures an Oregon Electric Railway train as it approaches the Multnomah Station. The Nelson Thomas building is in the center background. (Courtesy of the Oregon Historical Society Research Library, OrHi 47941.)

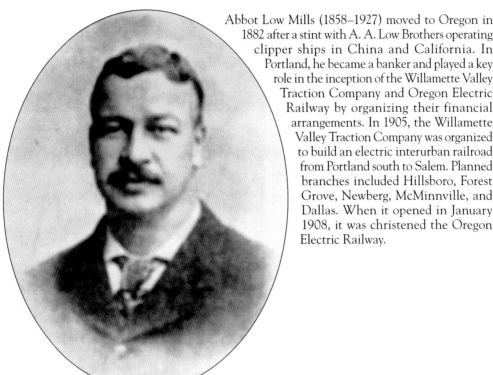

Abbot Low Mills (1858–1927) moved to Oregon in 1882 after a stint with A. A. Low Brothers operating clipper ships in China and California. In Portland, he became a banker and played a key role in the inception of the Willamette Valley Traction Company and Oregon Electric Railway by organizing their financial arrangements. In 1905, the Willamette Valley Traction Company was organized to build an electric interurban railroad from Portland south to Salem. Planned branches included Hillsboro, Forest Grove, Newberg, McMinnville, and Dallas. When it opened in January 1908, it was christened the Oregon Electric Railway.

The Oregon Electric Railway was financed, built, and operated by the railroad interests of James Jerome Hill (1838–1916). A hardworking and successful man, Hill aggressively entered the railroad business in 1877 after achieving success in both the coal and steamboat businesses. Hill became the chief executive officer of a family of lines headed by the Great Northern Railroad. Hill visited Portland periodically and was an ardent speaker on the benefits rail transportation would deliver to the city and state. This photograph of Hill was taken around 1890 when he was 52.

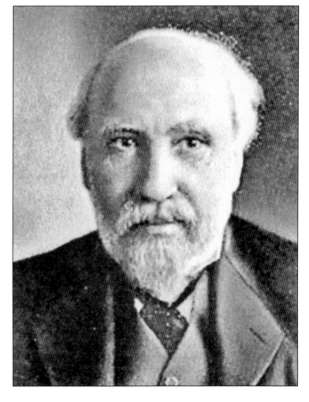

Construction of the Oregon Electric line to Salem and points along the Willamette Valley began in 1907. This view looking east toward Multnomah shows excavation for the new Oregon Electric near present-day SW Forty-fifth Avenue. (Courtesy of the Multnomah Historical Association.)

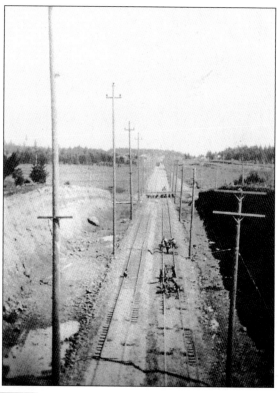

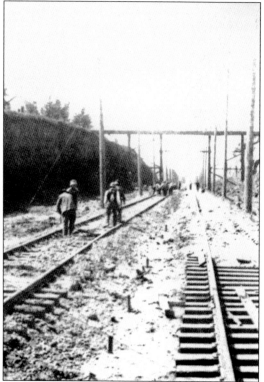

A portion of the Oregon Electric tracks was realigned around 1913. Taken just west of SW Forty-fifth Avenue looking west, this view shows work on new alignment. The temporary bridge connected to the Borsch property. William Borsch established a farm and nursery in 1892 on the west side of SW Forty-fifth Avenue north of SW Multnomah Boulevard, now the site of the Maplewood neighborhood. (Courtesy of the Multnomah Historical Association.)

Oregon Electric Railway Co

"WILLAMETTE ROUTE"
"THE ROAD OF COURTESY AND SERVICE"

OPEN FOR BUSINESS

WITH

2 DAILY TRAINS

BETWEEN

PORTLAND AND SALEM

Stopping at all intermediate stations. Trains from both Portland and Salem leave at 8 o'clock a. m. and 2 o'clock p. m., and arrive at 11 o'clock a. m. and 5 o'clock p. m. from temporary stations, corner of Front and Jefferson streets in Portland, and High and State streets in Salem.

Tickets for sale on trains or at the undersigned temporary offices, at the following

REDUCED RATES

Between Portland and Salem, single trip.....................$1.50
Between Portland and Salem, round trip....................$2.75
Between Portland and Salem, Saturday to Monday........$2.00
Between Portland and Salem, 25-ride family ticket........$25.00

Single, round-trip and 25-ride tickets on sale daily; return portion of round-trip tickets good for 30 days; 25-ride book ticket good for three months. Saturday-to-Monday tickets on sale for 2 o'clock train Saturday, or any train Sunday, good returning on any train of Sunday or the following Monday.

F. J. SWAYNE
Ticket Agent, Salem.

GEO. F. NEVINS
Traffic Manager.

An advertisement in the *Oregon Daily Journal* on January 28, 1908, informed Portland residents that daily train service between Portland and Salem, stopping at all intermediate stations, was now operating. Stations in previously unnamed locations along the line were given names of Native American origin, one of which was Multnomah Station. Multnomah is a Native American word first recorded by the explorers Lewis and Clark in their journals in 1805, where they spelled it "Mulknomah." The name designated a portion of the Willamette River as well as a tribe, village, chief, and, at one time, a large island in the Columbia River near the mouth of the Willamette River (now known as Sauvie Island).

In 1908, when Multnomah was developed, it was considered suburban. This rural character was part of its early attraction, as advertisements enticed new homeowners with the promise of "a little place of your own in the country to raise a garden and a few chickens." This *c.* 1910 photograph was taken from southwest of the location of the Multnomah depot. On the left, the Nelson Thomas Store is visible. The Oregon Electric tracks ran past the front of the Nelson store. On the right are the first few houses constructed south of what is now Multnomah Boulevard. (Courtesy of the Multnomah Historical Association.)

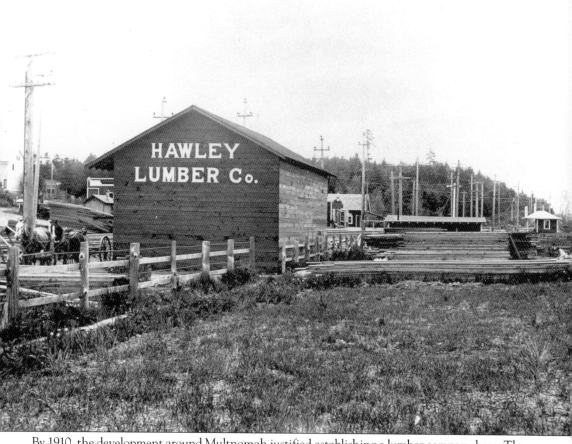

By 1910, the development around Multnomah justified establishing a lumber company here. The Hawley Lumber Company was located on the south side of the Oregon Electric tracks just west of the Multnomah depot and the Nelson Thomas Store. In this picture, the Lovejoy and Jackson store is visible in the left background. To the right of the Hawley building in the background is the Nelson Thomas building. (Courtesy of the Multnomah Historical Association.)

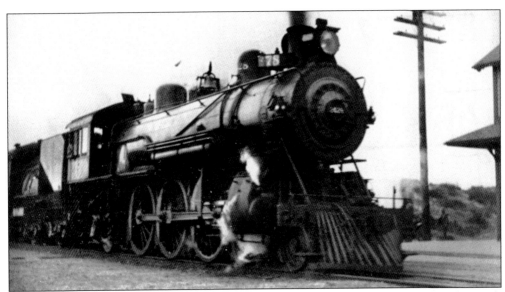

This Oregon Electric locomotive was used in the early 1900s. (Courtesy of the Multnomah Historical Association.)

Seven trains a day (except Sunday) ran between Multnomah and Portland, according to the 1929 schedule for the American Railway Express, which operated the Oregon Electric at that time. The trains started from the Oregon Electric Station at Tenth Avenue and NE Hoyt Street. Stations near Multnomah were Fulton Park, Capitol Hill, Ryan Place, Multnomah, Shahapta, Kusa (later Maplewood), Barstow, and Garden Home. Passenger service on the trains continued until 1933, when the decline in passengers, thanks to competition from automobiles and trucks, reached a point that the service could no longer be sustained. (Courtesy of the Multnomah Historical Association.)

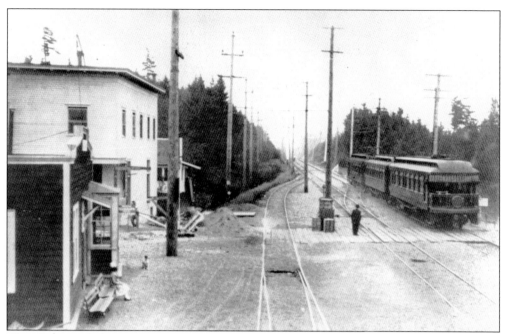

This photograph shows the Oregon Electric Railway train leaving Multnomah Station, pictured in the left foreground. The Nelson Thomas building is in the left background on the opposite side of what is now SW Thirty-fifth Avenue. (Courtesy of the Oregon Historical Society Research Library, OrHi 58549.)

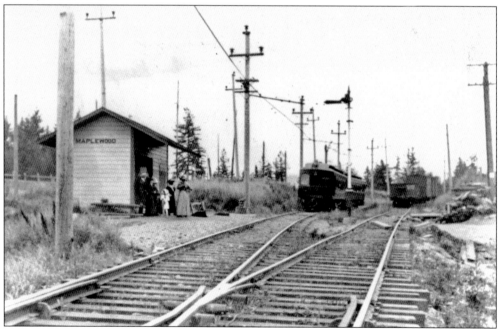

This is the Maplewood train station, the next stop south of Multnomah en route to Salem, in 1915, before the tracks were reconstructed on a straighter route. The passengers waiting for the train are Julia Schmitt (with the apron) and Margaret Wendland (little girl). (Courtesy of the Multnomah Historical Association.)

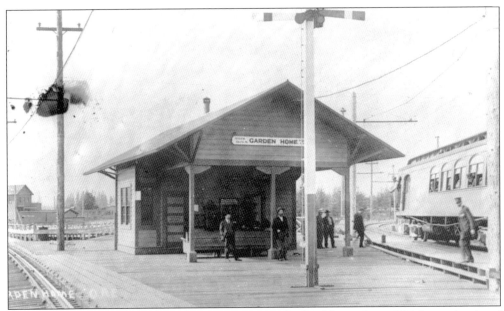

This view shows the Oregon Electric train station in Garden Home about 1915. Later the site of a cannery, it was eventually converted to the Comella and Sons greengrocer market. It is now the Old Market Pub. (Courtesy of the Multnomah Historical Association.)

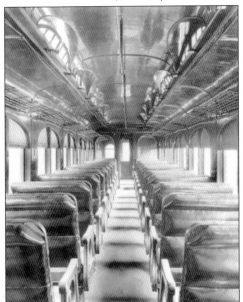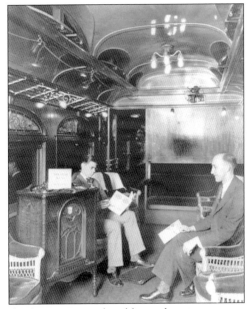

The Oregon Electric passenger cars were plush, and riders were comfortable on their journeys to Portland or points south. Leather-covered seats were spaced far enough apart to provide ample leg room; overhead racks provided space for packages and bags; clerestory windows along with side ones provided lots of light for reading, even in dreary, rainy weather; and every car included a toilet and a drinking fountain. The interior view at right shows the Oregon Electric Railway car *Champoeg* on the Luckenbach Special from Portland to Eugene in November 1929. On the left is an Atwater Kent Screen Grid Radio, on loan for the trip. Note the comfortable wicker armchairs. The man on the left appears to be reading the Spokane, Portland and Seattle Railway schedule.

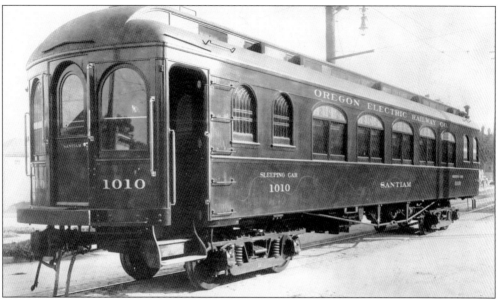

For passenger comfort on longer journeys, the Oregon Electric provided sleeping cars, such as the *Santiam*, pictured here.

Portland's Tenth Annual Rose Festival

Special Round Trip Tickets Sold Daily From All Points on the

Spokane, Portland & Seattle Ry., Oregon Trunk and Oregon Electric Ry.

REDUCED TICKET SALE DATES:

From all Oregon Electric stations June 4 to 9, inclusive.

From Oregon Trunk Ry. stations June 4 to 8, inclusive.

From North Bank Road points, Spedis to Spokane, Wash., June 4 to 8.

From North Bank Road points, Granddalles, Wash., to Rainier, Or., including Goldendale branch, June 4 to 9.

THREE DAYS
OF FROLIC AND
PAGEANTRY AND FUN.
NATIONAL
DEDICATION OF
COLUMBIA RIVER
FAMOUS HIGHWAY

Tuesday, June 6—
Crowning of Queen.

Wednesday, June 7—
School Children's Pageant.

Thursday, June 8—
Floral Pageant.
State Conventions.
Gun Club Shoot

Friday, June 9—
Military-Civic Pageant.
Speedboat Races

The railway made it possible for many suburban dwellers to participate in important civic celebrations and cultural events, as this advertisement for special Portland Rose Festival fares from the *Oregon Daily Journal* (June 7, 1916, page 6) shows. After the successful Lewis and Clark Exposition in 1905, the idea of a rose festival was proposed for 1907. It was such a success that a group of 10 businessmen, including Henry Pittock, publisher of the *Oregonian,* formally organized to plan and finance the Portland Rose Festival as an annual event.

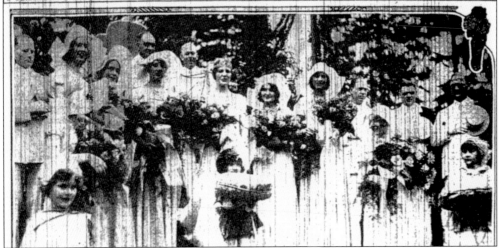

The Portland Rose Festival began its tradition of selecting its festival queen from the high schools of Portland in 1930. The first young woman to be so honored was 17-year-old Caroline Hahn of Lincoln High School, who grew up in Multnomah. All residents of Multnomah took great pride in her ascendance. Crowned Queen Caroline I, her first command during her reign was "Make everybody happy!" Her court included princesses Mildred Coe, Kathleen Sanders, Kathryn Conser, Essie Mitchell, Lucille Thomas, Reba Lee Moore, and Gene Dickinson. In the background, left of center, are Mayor George L. Baker and Roy Burnett, prime minister of the Rosarians. The crown bearer (in the center foreground) is four-year-old Janet Arnold. This photograph appeared in the *Morning Oregonian* on Friday, June 13, 1930.

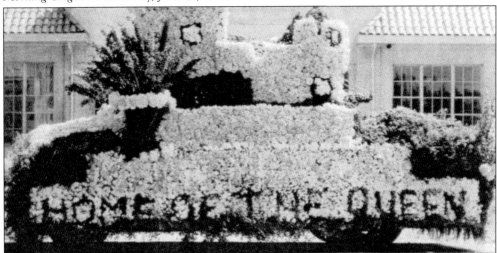

In 1930, Multnomah decorated a Portland Rose Festival float to honor their queen, Caroline Hahn, the daughter of Alexander T. and Francis Hahn of Multnomah. Caroline was a 1926 graduate of Multnomah School. Her mother, Francis, was one of handful of Multnomah women who, as recorded in Cecil R. Tulley and Marguerite Norris Davis's *The Building of a Community*, "climbed over rail fences, through brush, bramble and timber, and braved many a threatening dog, making their rounds of community homes and business houses" to obtain signatures on petitions for an elementary school to be established in the community. (Courtesy of the Multnomah Historical Association.)

40

Three

GROWTH AND PROSPERITY
1915–1928

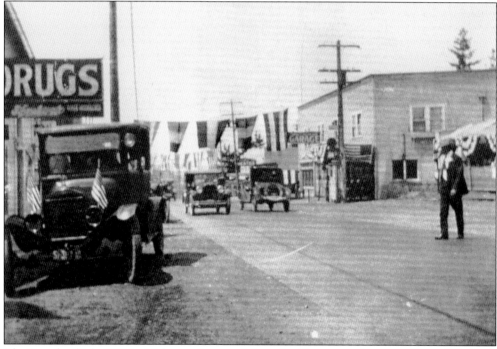

The Fourth of July 1916 in Multnomah was celebrated with great enthusiasm. Capitol Highway was recently paved, electricity and telephone service had come to the area in 1915, and gas was being installed—all reasons to celebrate. Everyone in the Portland area was invited, and thousands came. This photograph looks west along SW Capitol Highway from the intersection at SW Thirty-fifth Avenue. The large drugs sign on the left is on the front of the Ellis Pharmacy, and the Multnomah Garage is visible in the right background. Banners and flags are displayed over the street, from the buildings, and on cars. The gentleman on the right is also carrying a flag. (Courtesy of the Multnomah Historical Association.)

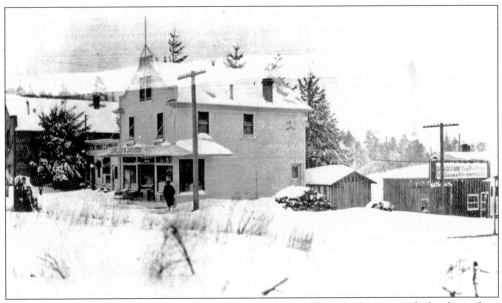

This view shows the Lovejoy and Jackson general merchandise, feed store, and plumber's shop at the intersection of SW Capitol Highway and SW Thirty-fifth Avenue in January 1919. Levi J. Lovejoy and James Blaine Jackson started the store about 1915. Shortly after this picture was taken, Lovejoy bought Jackson's share of the business and continued to operate the store as the L. J. Lovejoy Company. On the right is the Bungalow Feed Store, owned and operated by Nelson Thomas. (Courtesy of the Multnomah Historical Association.)

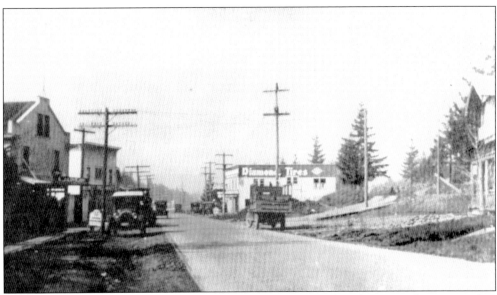

Motorists traveling to Multnomah from Hillsdale on SW Capitol Highway saw this view as they entered the village of Multnomah about 1919. On the left is the Lovejoy and Jackson general merchandise store; beyond it is the Ellis Pharmacy. On the right are a large log building, SW Troy Street, and the Multnomah Garage. (Courtesy of the Multnomah Historical Association.)

Lovejoy and Jackson created a calendar for their customers in 1916 with an amusing illustration titled "Courting Trouble." This was also the first year that the Lovejoy and Jackson store appeared in the grocery section of the Portland City Directory. Note that the calendar shows a telephone number for the store. While telephone service came to Multnomah around 1915, the service was described as "most unsatisfactory" for several years. (Courtesy of the Multnomah Historical Association.)

LOVEJOY & JACKSON
Groceries, Hardware, Plumbing and
Electrical Supplies
Phone, Main 5402, Multnomah, Ore.

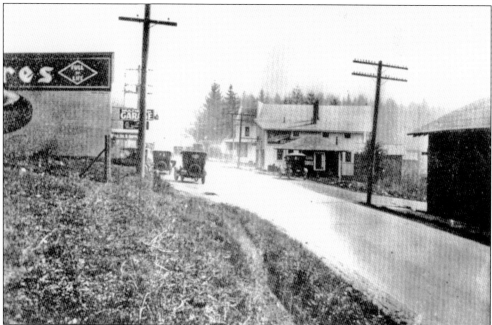

Looking east along SW Capitol Highway around 1919, the Multnomah Garage is on the left. The small building on the right is a real estate office. (Courtesy of the Multnomah Historical Association.)

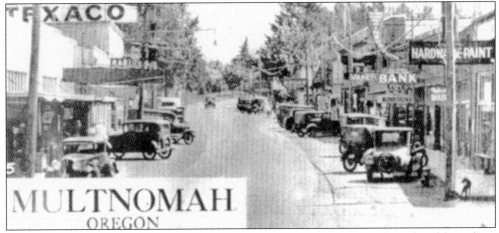

In the years between 1913 and 1925, passenger vehicle registration in Oregon skyrocketed from about 14,000 to over 120,000. This *c.* 1920 postcard of Multnomah Village shows the view looking east along SW Capitol Highway. The paving of Capitol Highway in 1915 greatly increased automobile traffic into and around the village. (Courtesy of the Multnomah Historical Association.)

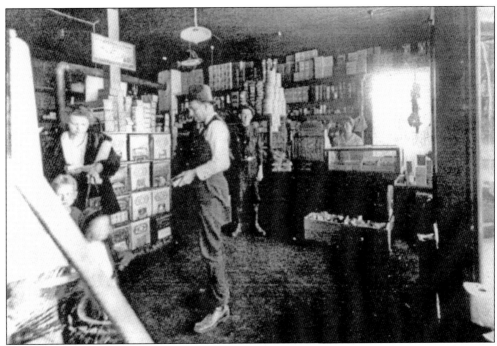

Levi J. Lovejoy is pictured here in his store waiting on a customer around 1921. Floyd Hiram Weatherly stands in the background, and Agnes H. Cadonau (of the Alpenrose Dairy Cadonau family) is behind the counter. Weatherly started working with Lovejoy delivering groceries, which could be a tedious job because the roads were nearly all unpaved and very muddy much of the time, but home delivery was a great convenience for customers. In 1929, Lovejoy sold his interest in the store to Weatherly. (Courtesy of the Multnomah Historical Association.)

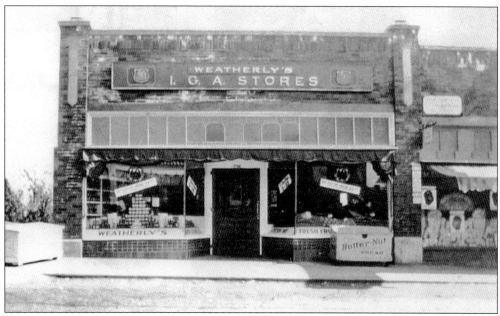

This view shows Weatherly's Independent Grocers Association (IGA) store near the intersection of SW Thirty-fifth Avenue and SW Capitol Highway about 1932. On the right is a drugstore. (Courtesy of the Multnomah Historical Association.)

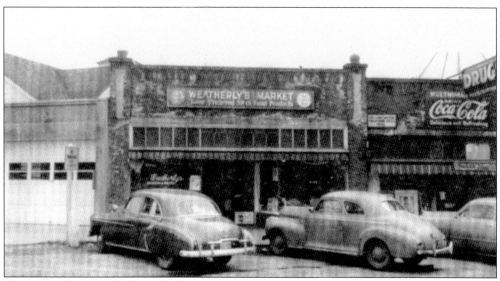

This c. 1937 photograph of Weatherly's Grocery shows the garage, left, used by the fire station, as well as updated signs over Weatherly's awning. (Courtesy of the Multnomah Historical Association.)

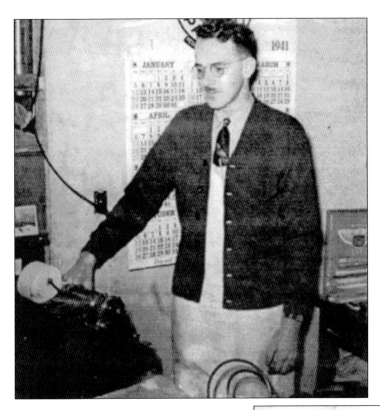

Floyd Hiram Weatherly kept an office at the grocery store; this image was taken around 1941. Weatherly was associated with the grocery in Multnomah for more than 25 years, from 1920 to 1947. (Courtesy of the Multnomah Historical Association.)

On December 31, 1940, Floyd H. Weatherly wrote a letter to his customers informing them that he was bringing his former butcher, Lawrence M. Bastian, into the business as his partner. In 1947, Weatherly sold his remaining interest in the store to Bastian. Shortly thereafter, Weatherly and his wife, Edith, retired to Scottsburg, Oregon, where he was born and raised. Weatherly died in Scottsburg on December 1, 1980. (Courtesy of the Multnomah Historical Association.)

WEATHERLY'S GROCERY
MULTNOMAH, OREGON

Dec. 31, 1940

Beginning January 1, 1941, Mr. Lawrence M. Bastian will be associated with me as a partner, he having bought from me an interest in the grocery and meat market.

I am happy to be able to make this announcement on starting my twenty-first year in the grocery business, serving the people of Multnomah and surrounding territory.

Lawrence has been my butcher for the last ten years, and is my oldest employee. He started over twelve years ago as a delivery-man, then a grocery clerk, and when I installed the meat department he was ready for the place, which he has taken an interest in, and worked hard to give our patrons good service and quality merchandise.

Lawrence has grown up with the store, and I believe in the future we will be able to serve you at a better advantage.

Thanking you for past favors, and assuring you that we are trying to make Weatherly's Grocery a better place to patronize,

Respectfully yours,

F. H. Weatherly

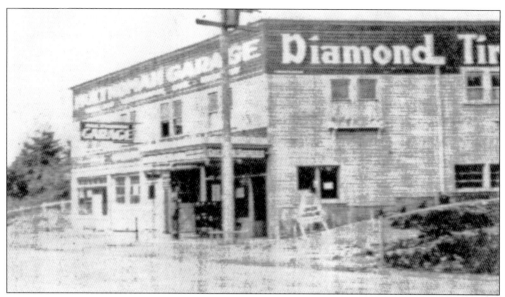

Automobile service companies were instrumental in fueling the rapid growth of auto ownership and use in the early 1900s. The Multnomah Garage was started by James Blaine Jackson after his partnership with Levi J. Lovejoy in the grocery business ended. Not too much later, around 1919, Jackson sold the garage to Roy C. Yonge. Jackson and his family then moved from Multnomah to Clackamas County, Oregon. (Courtesy of the Multnomah Historical Association.)

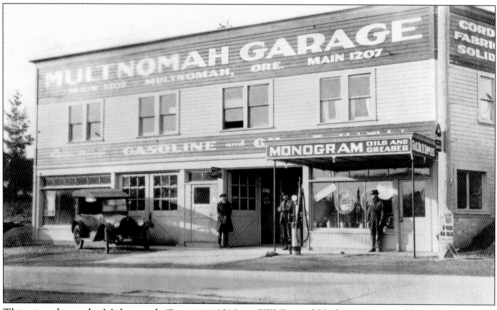

This view shows the Multnomah Garage in 1919 on SW Capitol Highway. Pictured here are, from left to right Frank Streeter, Frank Vegene, and Roy C. Yonge, owner. The Multnomah Garage was later sold; it became the Beardsley Garage. (Courtesy of the Multnomah Historical Association.)

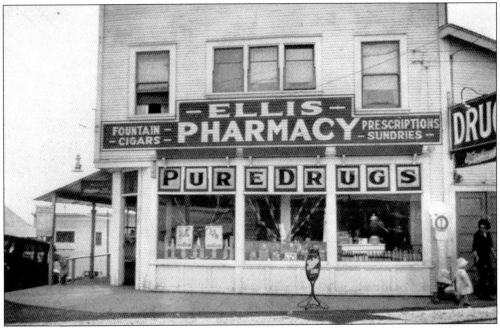

The Ellis Pharmacy occupied the southwest corner of SW Thirty-fifth Avenue and Capitol Highway. This building, called the Pfeiffer Building, was home to the Ellis Pharmacy from 1924 to 1929. The photograph was taken about 1927, after cement sidewalks were poured. (Courtesy of the Multnomah Historical Association.)

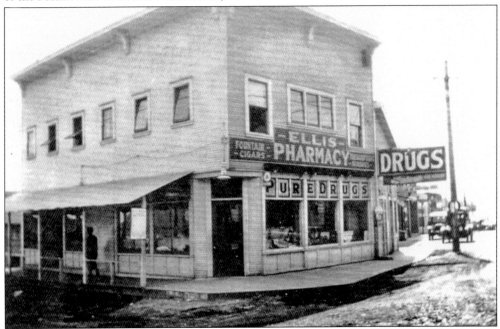

This view of the Ellis Pharmacy on the southwest corner of SW Thirty-fifth and Capitol Highway, taken about 1927, shows the veranda on SW Thirty-fifth Avenue. This is the view motorists would see as they drove from the east into Multnomah. It would be hard to overlook this business. (Courtesy of the Multnomah Historical Association.)

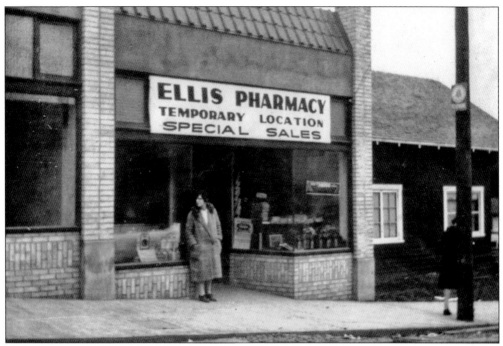

The Ellis Pharmacy moved to a temporary location, 7828 SW Thirty-fifth Avenue, during the time that the old Pfeiffer Building was demolished and the Ellis Building was constructed in 1929. (Courtesy of the Multnomah Historical Association.)

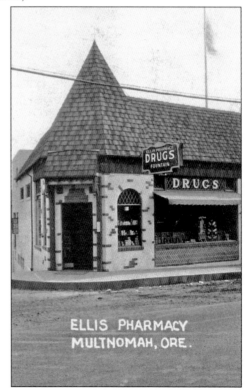

The new Ellis Pharmacy building featured this distinctive cone-shaped roofline. This photograph was taken just after the pharmacy moved into its new building in 1929. The new building was one story tall with space for two stores. (Courtesy of the Multnomah Historical Association.)

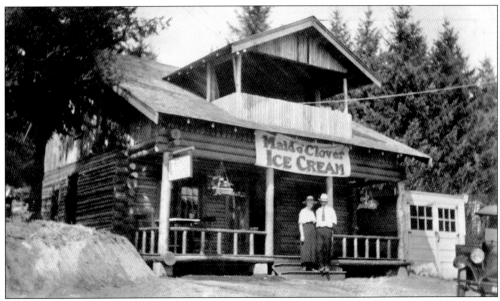

In 1920, the Maid O'Clover Ice Cream shop occupied the first floor of a large log building at the northeast corner of Capitol Highway and SW Thirty-fifth Avenue. The log building was removed by 1926. (Courtesy of the Multnomah Historical Association.)

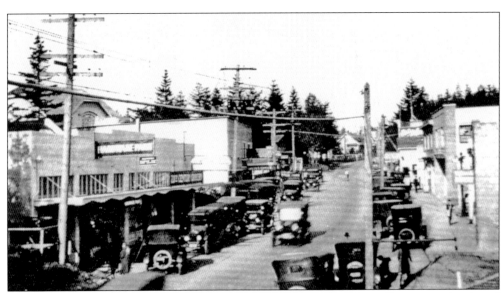

Looking east along SW Capitol Highway around 1924, automobile traffic appears brisk and parking well utilized. The conclusion is that the village was a destination, not just a location to pass through. In the background on the left side of the highway, the Maid O'Clover's log home is visible. (Courtesy of the Multnomah Historical Association.)

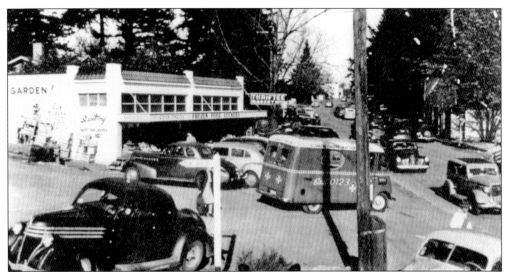

This building, constructed in 1926, replaced the large log structure that had previously been in this location. The Thriftee Market, pictured here around 1933, moved into the building after the original tenant, the Multnomah Drugstore, moved across the street in 1932 to a new structure that they had built on the southeast corner of SW Thirty-fifth Avenue and SW Capitol Highway, next to the new Weatherly's Grocery store. (Courtesy of the Multnomah Historical Association.)

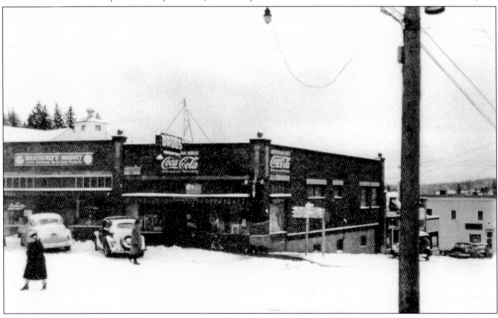

The original Lovejoy and Jackson store was on the corner, and a lean-to was adjacent to it on the left. In the late 1920s, Lovejoy had the lean-to torn down, and a new store was built on the site, leaving the old Lovejoy store on the corner. Around 1930, William A. Siegfried bought the old Lovejoy store, had it torn down, and erected a new drugstore building on the site. When completed, it matched the Weatherly Grocery building next door. The new fixtures included a big electric sign directing people to the new store. This photograph was taken about 1932, shortly after the Multnomah Drugstore moved into their new building. (Courtesy of the Multnomah Historical Association.)

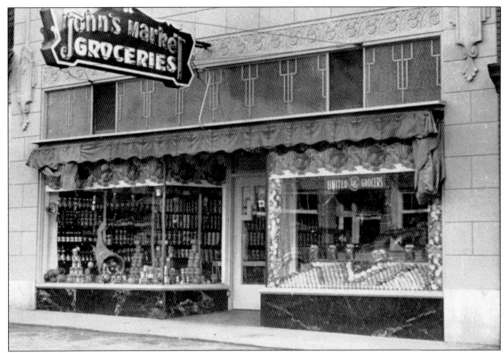

John's Market began in 1922 when John Feuz purchased James Sullivan's meat market business and building, which also provided office space for A. E. Gillett Realty. John's Market and Grocery occupied this location on Capitol Highway for 17 years before extensively remodeling it in 1939. This photograph shows the building in 1939 after the remodeling. In 1957, the market moved down the hill to a new building constructed on the site of the old railroad depot. Since John's Market moved to Multnomah Boulevard in 1957, the building has been occupied at different times by several businesses, including Crawford's Apparel, Multnomah Mercantile, and Le Meitour Gallery. (Courtesy of the Oregon Historical Society Research Library, OrHi 44505.)

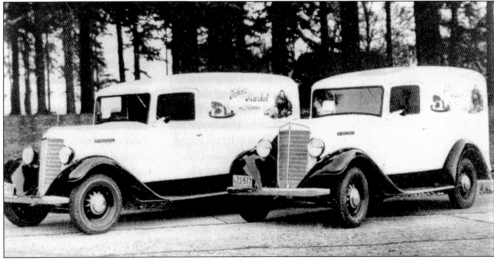

John's Market began making wholesale and retail deliveries in the 1920s. By the 1930s or early 1940s, business was good enough to keep two delivery trucks busy. (Courtesy of the Multnomah Historical Association.)

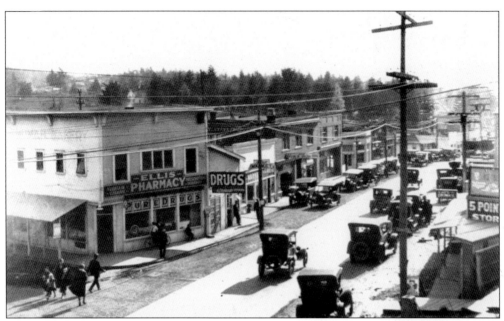

Before 1915, getting around Multnomah in an automobile was not easy. Slavin Road (later called Capitol Highway) had some gravel, making it better than a muddy track, but not much, and some sections were covered with logs (called corduroy). In 1915, Capitol Highway was surfaced with concrete, one of the first roads in the entire state to be so treated. It was more or less a test case, and it proved to be a successful one. After the concrete was poured, it was covered with straw and allowed to cure for a month before being used. The new highway, along with other transportation improvements (such as the completion of several bridges across the Willamette River), boosted vehicle ownership. Automobile traffic on Multnomah Village's "main street," about 1924 looking west toward the Oregon Electric railway crossing, is significant. (Courtesy of the Multnomah Historical Association.)

Harry C. Webster, proprietor of the 5 Point Store, a confectioners store (on the far right in the previous photograph), is moving a heavy box of Sealright using a wheelbarrow. The store is pictured at right. Note the painted advertisements for Maid O'Clover butter (behind Webster) and ice cream (on the store wall on the right). (Courtesy of the Multnomah Historical Association.)

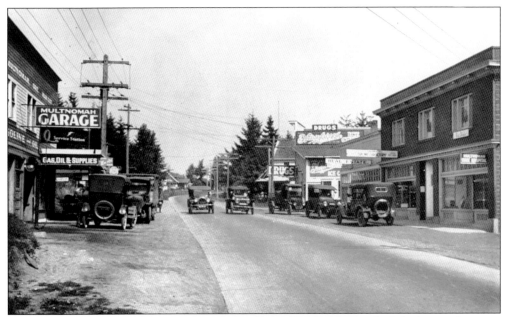

In this view of Capital Highway in 1924, the Multnomah Garage is on the left. Across the street are the Ellis drugstore, John's Meat Market (owned by John Feuz), a real estate office, a grocery store, and the Multnomah Shoe Hospital. The most popular models of cars in Portland in the 1920s, based on the brands automobile dealers advertised, were Hupmobiles, Maxwells, Overlands, Pierce-Arrows, Oaklands, Franklins, and Willys-Knights. (Courtesy of the Oregon Historical Society Research Library, OrHi 48011.)

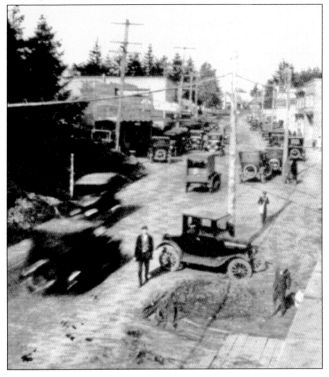

This view shows SW Capitol Highway in 1925, looking east from a location near the Oregon Electric crossing at SW Twenty-seventh Avenue. A mail carrier or newspaper delivery boy stands in the front right. (Courtesy of the Multnomah Historical Association.)

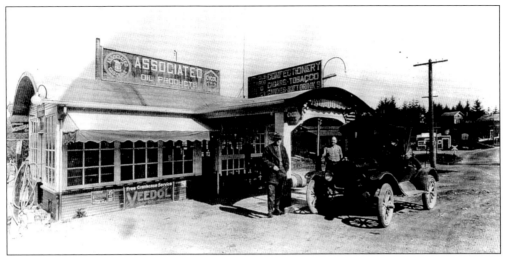

Pictured here c. 1919, the first gas station in Multnomah stood near the intersection of SW Twenty-seventh Avenue and the Oregon Electric tracks and was owned and operated by Mark Barron. Note the railroad crossing sign visible in the right background. The location is now the site of Handy Andy's. (Courtesy of the Multnomah Historical Association.)

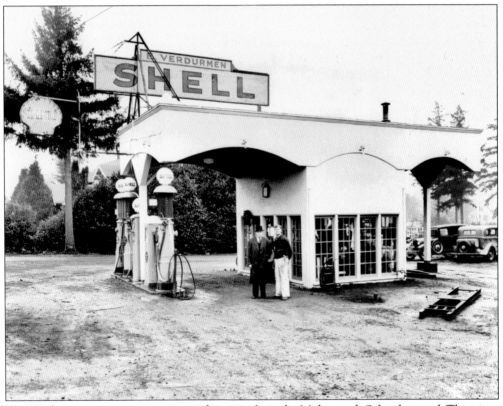

The Verdurmen gas station was across the street from the Multnomah School ground. This view, made before 1924, includes a glimpse of the school grounds in the background, where one can see only trees. (Courtesy of the Multnomah Historical Association.)

Two portable buildings were the first classrooms for Multnomah School, which opened its doors in 1913. The school grew to four portable buildings before a permanent building was erected on the site. (Courtesy of the Multnomah Historical Association.)

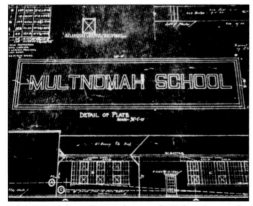

The 1923 plans for Multnomah School specified that a 320-foot-wide building would replace the four portable ones. The new school, designed by C. L. Goodrich, contained 10 classrooms, an auditorium with stage, a manual training room, a domestic science room, two play sheds for boys and for girls, a teacher's lounge, a principal's office, restrooms, and a boiler room. (Courtesy of the City of Portland Archives.)

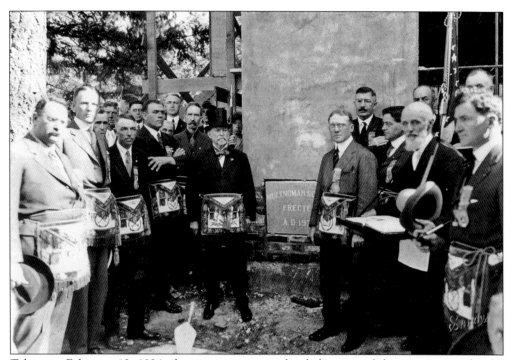

Taken on February 12, 1924, this image captures the dedication of the cornerstone for the Multnomah School. The program committee asked the Masons, whose new building across the street was almost complete, to dedication the building. The event was attended by nearly all residents of the community, who were very excited to see the school they had worked so hard to have built. (Courtesy of the Multnomah Historical Association.)

The Orenomah Masonic Lodge was established in 1921, the 177th Masonic Lodge in the state of Oregon. This photograph shows key members of the lodge about 1940; the specific occasion is not known. The lodge building was built in 1924 across the street from the Multnomah School, and building activities for the two structures were concurrent for some time. The name "Orenomah," a combination of Oregon and Multnomah, was selected to differentiate this lodge from one named Multnomah located in Oregon City. (Courtesy of Tigard Orenomah Masonic Lodge No. 207.)

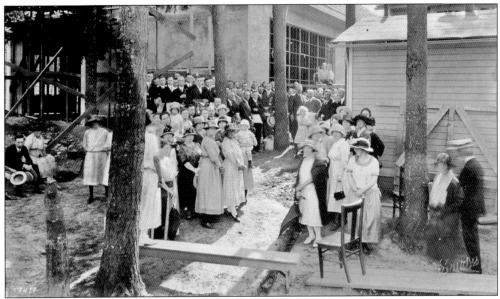

The new Multnomah School was dedicated on February 12, 1924, and many of the attendees were parents who had worked hard to support the building of the school. (Courtesy of the Multnomah Historical Association.)

The Orenomah Masonic Lodge has been a landmark in Multnomah since it was built in 1924. Multnomah's Orenomah masons were distressed to learn in 1996 that, for various reasons, the structure no longer met requirements imposed on public buildings. Because the cost of improvements was beyond the means of the chapter, Orenomah Lodge No. 177 merged with Tigard Lodge No. 207 in 1997 to form the combined Tigard Orenomah Lodge. Their building was sold "as is" and, after a long period of disuse, it reopened as the Lucky Labrador Pub in 2005. The imposing exterior remains unchanged, with the exception of the Lucky Lab logo replacing the Masonic symbol on the facade of the building.

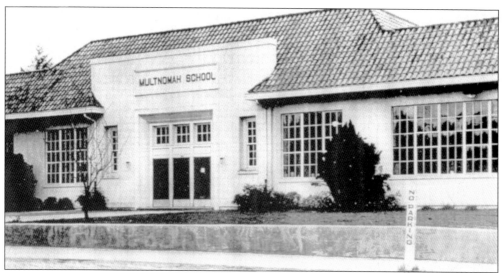

This photograph of the Multnomah School was taken about 1932. The planting of the cherry tree to the left of the front entrance was newsworthy enough to be covered in the April 9, 1932, issue of the *Oregonian*. (Courtesy of the Multnomah Historical Association.)

During the dedication of the Multnomah School 1924 and during most of the construction of the Orenomah Masonic Lodge across the street, the worshipful master of Orenomah Lodge No. 177 was Multnomah resident John Pembroke Gault. He took office on St. John's Day, December 27, 1923, and served through December 1924. Born in 1888 and raised in Tigardville (now Tigard), Gault was a salesman for a wholesale mill who commuted to his job on the Oregon Electric. He lived with his wife, Faye, and family in the Ryan Place section of Multnomah. (Courtesy of the Tigard Orenomah Masonic Lodge no. 207.)

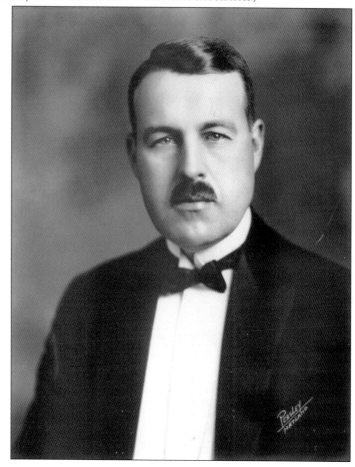

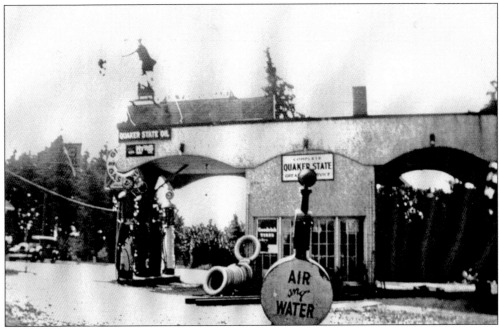

This pre-1924 view of the Verdurmen gas station looks across SW Thirty-third Avenue. Behind the laurel hedge, the dormers of the house used for living quarters and office space first by Dr. John Loomis and later by Dr. H. V. Thatcher are visible. (Courtesy of the Multnomah Historical Association.)

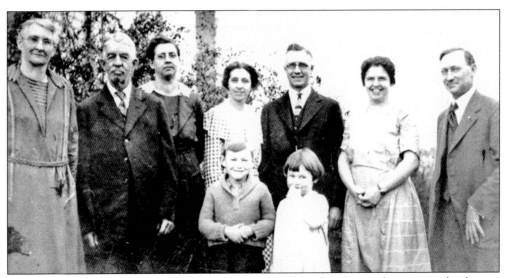

Multnomah has been the home and workplace for a number of professionals, in particular doctors and dentists. Dr. John Leo Loomis and his wife, Hazel Johnson Loomis, settled in Multnomah about 1915, two years after Hazel's parents, Festus Sylenus and Martha Ann McCullough Johnson, established a small farm on Capitol Highway. Dr. Loomis was the only physician in Multnomah during the 1918–1919 outbreak of influenza. Here Dr. Loomis and family are standing in front of the Loomis home across the street from Multnomah School about 1922. Children John Wayne and Joyce attended school in Multnomah. (Courtesy of the Multnomah Historical Association.)

Between 1899 and 1915, the number of radio stations in U.S. skyrocketed, and the technology for building receivers made better, less expensive models possible. The Pownder Radio Company located on SW Capitol Highway in Multnomah sold top-of-the-line radios made by the Majestic Electric Radio Company, as seen in their advertisement in the August 1929 Pacific Telephone and Telegraph Company Telephone Directory.

On April 6, 1917, Congress declared war on Germany to aid the Allied forces in Europe and help win the war against the Central Powers. The United States had a regular army of only 200,000 men. With the need for a larger army, Congress passed a Selective Service Act that made all able-bodied men between the ages of 21 and 30 subject to military service. William Arthur Denley of Multnomah, age 24, son of the Denley dairy farm family, was one of the local men who registered with the draft board.

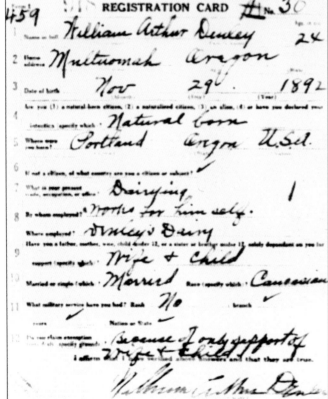

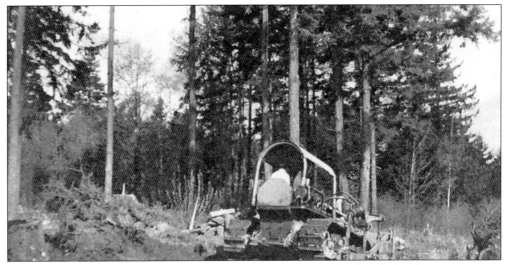

Breaking ground for new homes in Multnomah in the 1920s was hard work thanks to many trees, lots of brush, and often muddy conditions. Pictured here is a lot at the corner of SW Thirty-seventh Avenue and SW Alice Street. In 1900, Portland ranked 26th among large American cities in the percentage of households that owned their own homes; 10 years later, Portland ranked fifth in the nation with 46 percent owning homes compared to 32 percent for all other large cities. Homeownership boomed in Portland between 1905 and 1912. (Courtesy of the Multnomah Historical Association.)

In the foreground is Mr. Schabolt, builder, who was responsible for constructing a house on SW Thirty-seventh Avenue and SW Alice Street. (Courtesy of the Multnomah Historical Association.)

In this *c.* 1923 photograph, Glenn Day is digging the basement for the home at 4208 SW Hume Street by hand. (Courtesy of the Multnomah Historical Association.)

Many homeowners in Multnomah did as much of the construction work on their homes as they were able. This view shows homeowner Glenn Day working on his home at 4208 SW Hume Street in 1923. (Courtesy of the Multnomah Historical Association.)

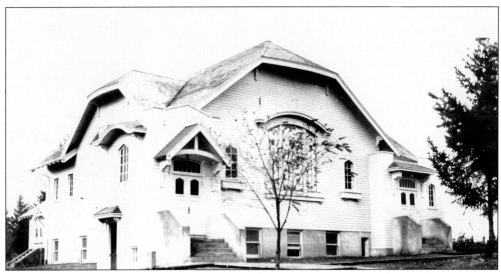

The Multnomah United Presbyterian Church, which called itself the Multnomah Community Church, was built in 1921 and dedicated on November 6 of that year. Seen here in 1921, it was located at the corner of SW Troy Street and SW Thirty-fifth Avenue, where the Key Bank now stands. When this church was formed, there were no other churches in the area, and it hoped to serve churchgoers of all denominations even though most of its first members (by a small margin) were Presbyterian. The final service at this church was held on January 19, 1958. (Courtesy of the Multnomah Historical Association.)

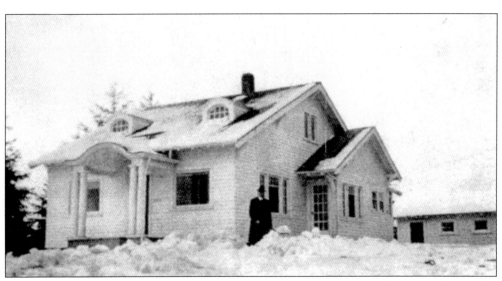

The parsonage for the Multnomah Community Church was built around 1922. In front of the house is Rev. David Steele Sharpe, who was pastor from 1920 to 1929. (Courtesy of the Multnomah Historical Association.)

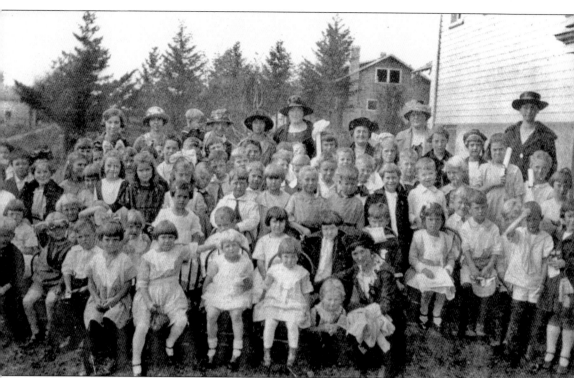

Sunday school classes gathered outside the Multnomah Presbyterian Church with their teachers in 1924. In the background is the Swanson house. Included in the picture are (first row) Clarence Pownder, Robert Voit, Frances Maul, Ruth Yonge, Maryann Long, Margaret Yonge, Stewart Forbes, and Mrs. G. Forbes; (second row) Bessie Nelson, Jean Burke, Eileen Niederer, Delores DeLong, Roy Yonge Jr., ? Boyd, Bernice Updike, Mary Notis, Fred Voit, Shelton Wishart, and Bill Weatherly; (third row) Emma Hogue, Anita Powell, Margaret Rhue, Jean Allen, Doris Weidemann, Ralph Yonge, Homer Neiderer, Genevive Foster, Erma Keiling, Glen Pownder, Earl Heim, Howard Heim, Norma Burke, Virginia Saunders, and Evelyn Pownder; (fourth row) Phyllis Frost, Elmer Shick, Anita Swanson, Donald Cadonau, Don Buston, John Long, John Spencer, Harold Schick, Lawrence DeLong, Doris Lacey, Hazel Wishart, Dean Parker, and Erma Nagel; (children in the fifth row) Joan Leslie, ? Dunn, and Gretchen Hurn; (teachers in the fifth row) Charlotte Cob, Frederica Weatherly, Alpha Haffenden holding her son Robert, Lulu A. Maul, Mrs. Parker, Mrs. Dillard, Mrs. Dunn, and Mrs. Hardy. (Courtesy of the Multnomah Historical Association.)

Throughout the early years of Multnomah development, clean water was a problem. Most water was supplied from hand-dug wells and surface water, often erratic in supply and uncertain in cleanliness and quality. Historians Marguerite Norris David and Cecil R. Tulley state, "The struggle to obtain Bull Run water was the longest and most difficult of any in which the pioneer home owners and other progressive-minded men and women engaged to obtain needed utilities for the community." After sustained efforts by community boosters such as Chester Ehle, Bull Run water was supplied to the community for the first time in 1913. This 1961 view shows the original Texas Street water tank, a storage reservoir for Bull Run water, which was built in the early 1900s and had a capacity of 200,000 gallons. The City of Portland acquired the tank from the Home Water District on December 31, 1952. (Courtesy of the City of Portland Archives.)

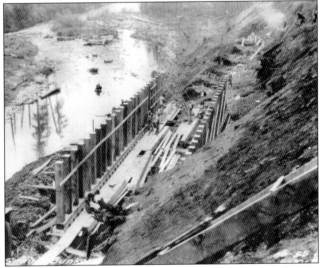

The Bull Run watershed was tapped to supply water to Portland in 1895, an accomplishment that Multnomah residents envied. The watershed is part of the Mount Hood National Forest, covers 102 acres, and provides water of exceptional cleanliness and quality. Even current federal regulations exempt Bull Run water from filtration requirements because of its high quality. The original water system consisted of Bull Run Lake (a natural lake) and the Bull Run River. To meet increased demand as the city grew through annexation, dams were erected to create reservoirs in the watershed, with the first being constructed in 1927. (Courtesy of the Portland Bureau of Water Works.)

Four

HARD TIMES
1929–1939

MULTNOMAH BANK WILL BEGIN PAYING

Every Depositor to Get 100 Cents on Dollar.

BY LEON B. BAKETEL
Financial Editor, The Oregonian.

Voluntary liquidation of the Multnomah Commercial & Savings bank, located at Multnomah, with every depositor being paid 100 cents on the dollar and none losing 1 cent, was announced yesterday by Henry Raz, president.

The institution, which was established in 1923 and for the past 11 years has been owned by Mr. Raz, has been operating on a restricted basis since the banking holiday. Decreased volume of business and inability to obtain backing from the Federal Deposit Insurance corporation prompted Mr. Raz and his directors to take this step.

LIQUIDATION TO START

Liquidation will be started this morning with depositors being paid off either by draft on the bank's Portland correspondent or in cash.

Deposits were received yesterday, Mr. Raz stated, but with the close of business in the afternoon, further activity of the institution as a bank ceased. For the next few days nothing will be done but pay off the deposits in the commercial department, which total around $30,900. All savings depositors were paid in full shortly after the 1933 holiday.

At the high spot in its career, the bank had commercial and savings deposits in excess of $325,000. This was early in 1933. Since then they gradually have diminished.

BIG SACRIFICE MADE

Heroic efforts were made by the officers and directors, A. A. Schramm, state superintendent of banks, said, to keep the bank going. The owners sacrificed most of their property to keep the institution liquid and to meet two assessments levied against them.

For the present Mr. Raz proposes to operate an exchange in Multnomah. He will continue the safety deposit vault, will cash checks and make change for firms of that community, but no deposits will be accepted.

The Multnomah Commercial and Savings Bank opening in 1923 delighted Multnomah residents and merchants alike. When the bank was forced to close in 1934, their optimism was crushed. The good news that the bank would pay every depositor 100¢ on the dollar was remarkable enough to make the front page of the *Morning Oregonian* on Friday, December 28, 1934. This promise was made and kept largely due to the honor and integrity of Henry Raz, who with a group of businessmen and friends had founded the bank. The Great Depression adversely impacted the bank, like many others, but its failure was largely the result of imprudent actions by experienced and supposedly fiscally responsible financiers whom the board had hired to manage the bank's day-to-day operations. In an attempt to remedy its problems, Henry Raz turned his personal deposits over to the bank, gave up his $100-a-month salary, and, with his family, gave personal notes to the people the bank owed. Despite his heroic efforts to save the bank, the Federal Deposit Insurance Corporation (FDIC) declined to insure it in 1934, thus mandating that it close.

Henry Raz (1870–1948) was the youngest of 12 children born to John and Anna Frutiger Raz. Along with several other businessmen, he started the Multnomah Commercial and Savings Bank in 1923. In addition, he operated a farm, was active in real estate development, and helped to bring many of the first roads and utilities to the area. He married Susette Kleger in 1904, and their children included Henrietta (bottom row, right) and, from left to right in the second row, Matilda, Calvin, Walter, and Paul Raz. (Courtesy of Multnomah Historical Association.)

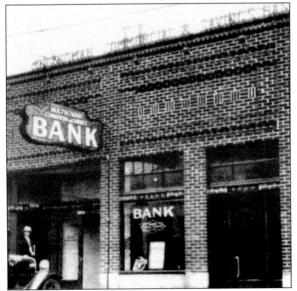

In the early 1920s, business in the area around Multnomah was picking up, and merchants in the area were talking about the need for a new bank to fully serve this area. In 1923, Henry Raz, along with William Borsch, Ben Riesland, E. J. Berneche, and E. E. Fitzwater, started the Multnomah Commercial and Savings Bank. They constructed a new building to house the bank on SW Capitol Highway across the street from where a theater and another new building were under construction. The bank officially opened for business January 2, 1924. (Courtesy of the Multnomah Historical Association.)

In its early years, the bank was quite successful and so presented a tempting target as difficult economic times descended. On May 14, 1931, the Multnomah Commercial and Savings Bank was robbed at gunpoint. The lower right corner of the composite photograph shows bank employees Walter Raz (son of Henry Raz), Ruth Doescher, and John Kort. Despite the fact that employees Walter and Werner Raz (cousins) were concerned about robbery and had taken steps to become practiced at handling guns and shooting, everyone in the bank was taken by surprise. Between $1,000 and $1,500 was taken, and though the police located the car used in the robbery, the thieves were never caught. (Courtesy of the Multnomah Historical Association.)

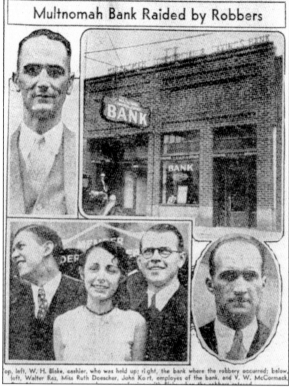

Multnomah Bank Raided by Robbers

op, left, W. H. Blake, cashier, who was held up; right, the bank where the robbery occurred; below, left, Walter Raz, Miss Ruth Doescher, John Kort, employes of the bank, and V. W. McCormack,

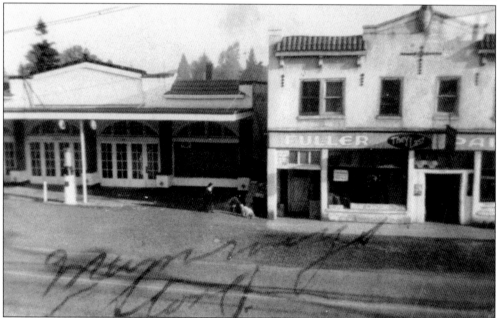

This image of the Ross Motor Company Ford dealership (left), built around 1928, and the Fuller Paint store was taken from a second-story window in Dr. Nelson's office about 1939 or 1940. Dr. Nelson was a Multnomah dentist whose office had a view over Capitol Highway between SW Thirtieth Place and SW Thirty-first Avenue. (Courtesy of the Multnomah Historical Association.)

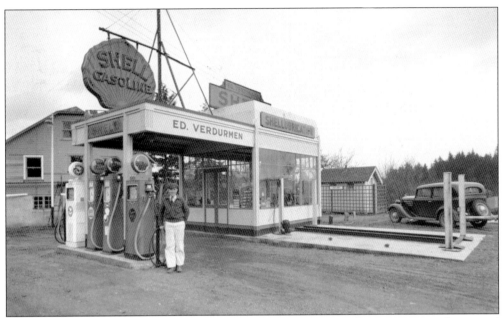

In this photograph, Melvin M. Brunson stands by a gasoline pump at the service station he opened in 1935 and operated until 1939. Note his 1934 Chevrolet parked near the restrooms. He purchased the car in 1936 and traded it for a 1938 Chevrolet in 1940. The price of gasoline was 19, 21, or 23¢ per gallon, depending on the grade. (Courtesy of the Multnomah Historical Association.)

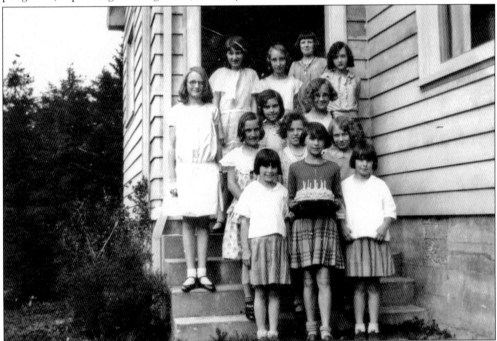

In 1931, this group of girls gathered at 3640 SW Spring Garden Street to celebrate the 12th birthday of June England (holding the birthday cake). June is the daughter of George, who worked as a car inspector for the railroad, and Kathryn England. (Courtesy of the Multnomah Historical Association.)

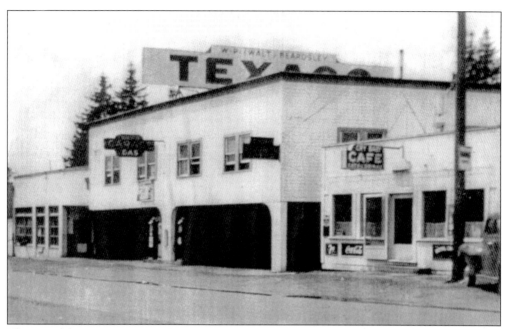

The Beardsley Garage, owned by Walter P. Beardsley, replaced the Multnomah Garage, and it later became Beardsley Auto Parts, which operated until a devastating fire in 1977. (Courtesy of the Multnomah Historical Association.)

This picture was taken in 1937, when Walter P. Beardsley, operator of the Beardsley Garage, became worshipful master of Orenomah Masonic Lodge No. 177. Walter, his wife Mildred, daughter Betty Jean, and mother-in-law lived on SW Moss Street, named for Sidney Walter Moss, a surveyor hired by Dr. John McLoughlin to survey Oregon City. Moss came to Oregon in 1842 and opened the first hotel west of the Rocky Mountains to accommodate Oregon Trail newcomers. He operated the first livery stable in Oregon City and financed the first school there. He also authored what was probably the first novel written in Oregon, *Prairie*. Moss died in 1901. (Courtesy of the Tigard Orenomah Masonic Lodge No. 207.)

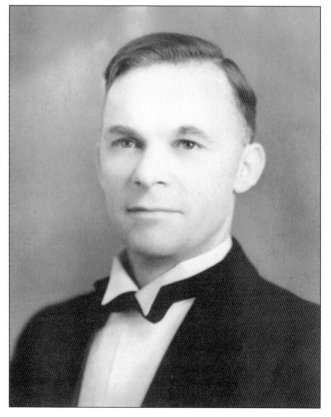

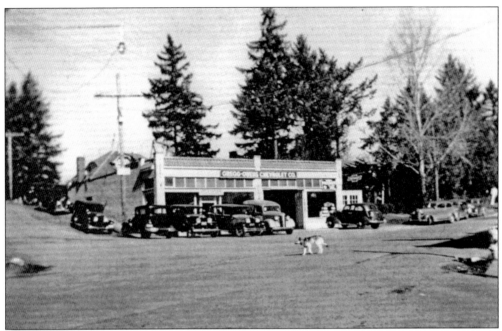

This 1937 or 1938 photograph shows the Gregg-Owens Chevrolet Company on the northeast corner of SW Thirty-fifth Avenue and SW Capitol Highway. The dealership moved to SW Barbur Boulevard about 1942; it was later bought out by Ron Tonkin. (Courtesy of the Multnomah Historical Association.)

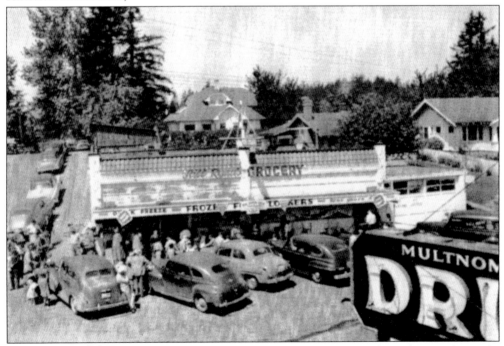

The northeast corner of SW Thirty-fifth Avenue and SW Capitol Highway became home for Ryan's Grocery market about 1952. The sign for the Multnomah Drugstore, across the street, is in the foreground. (Courtesy of the Multnomah Historical Association.)

Five

ANNEXATION BY PORTLAND

1940–PRESENT

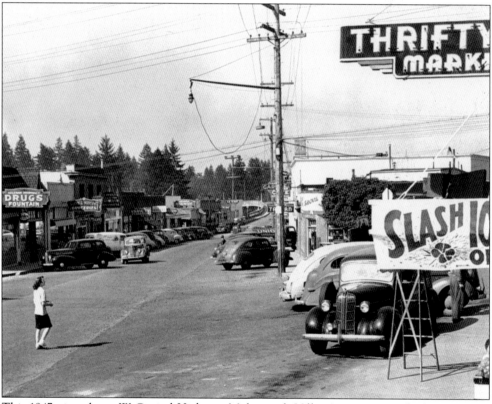

This 1947 view shows W Capitol Highway, Multnomah Village's main street, looking west, as Beverly Jean Armitage Davis crosses the street. On the left side of the street are the Alderman Pharmacy, John's Market, Al Call's Ice Cream, a radio/electric store, a real estate office, Multnomah Bakery, Multnomah Tavern, Multnomah Hardware Company, the Multnomah Shoe Shop, and Clipper Cleaners. On the right are the Thriftway Market, a flower shop, Renner's Grill, a café, and a garage. (Courtesy of the Oregon Historical Society Research Library, OrHi 44507-a.)

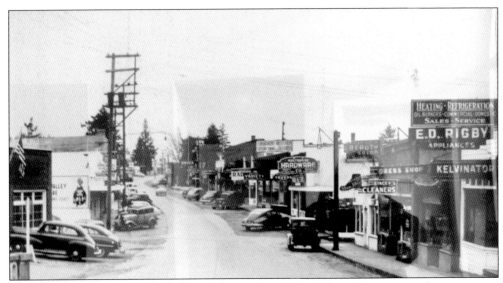

A post office was first established in Multnomah in 1912; Nelson Thomas was the postmaster and the post office was in his store. The second post office was in the Hawley Lumber Company, and John Hawley was the postmaster. In 1939, the post office occupied a small brick building on SW Capitol Highway, seen in this photograph on the far left. Werner Raz was postmaster at this time.

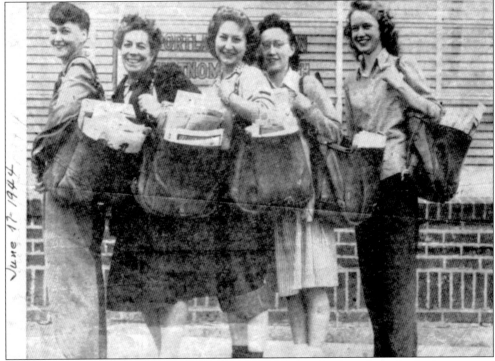

The absence of two regular postmen on June 11, 1944, opened a door through which women of Multnomah walked. For a short time in 1944, (from left to right) Lillian Sears, Iva Woodward, Patricia Long, Emma Wargi, and Virginia Schaaf were an all-female mail delivery team—believed to be the first in the country. (Courtesy of the Multnomah Historical Association.)

Taken on V-E Day (May 8, 1945), this photograph shows Oregon serviceman William P. Borden in Austria holding a small child. After Borden returned to the U.S. and left the service, he settled in Multnomah with his wife, Naomi. (Courtesy of the Multnomah Historical Association.)

In 1944, William Arthur Denley was made worshipful master of the Orenomah chapter of the Masons. (Courtesy of the Tigard Orenomah Masonic Lodge No. 207.)

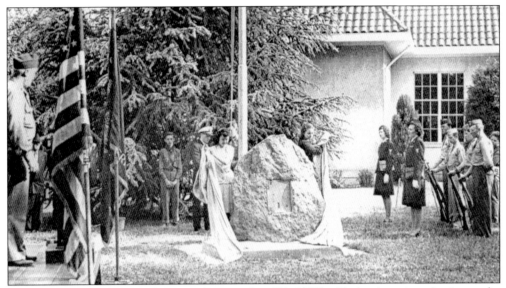

To honor the people from the area who served in World War II, the American Legion and a group of local citizens placed a large rock, found near Multnomah Falls in the Columbia Gorge, on the front lawn of the Multnomah School. Behind a bronze commemoration plaque, an urn enclosing a scroll listing the names of those honored was embedded in the rock. The rock was dedicated on May 19, 1946. Emilena Honegger and Sylvia Senn, American Legion honor girls, unveiled the monument. The plaque on the rock reads, "This memorial is erected in honor of all men and women from this community who served God, country and the case of freedom during World War II. . . . These have served and we have entered the fruits of their service." (Courtesy of the Multnomah Historical Association.)

A second water tank was built on the Texas Street site in 1948, seen in the foreground of this 1965 photograph. Made of concrete, the second tank has a capacity of 615,000 gallons of water. The tank continues to serve the area south of Vermont Street and west of Terwilliger Boulevard. The older tank, still visible here, was removed sometime between 1965 and 1980. (Courtesy of the City of Portland Archives.)

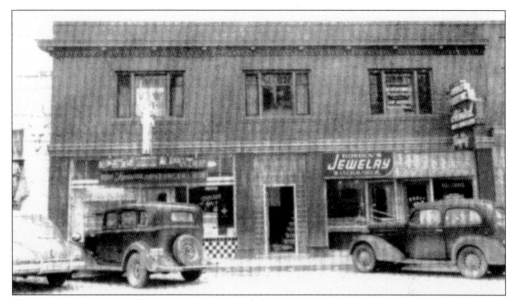

This image shows Al Call's Ice Cream store and the Borden Jewelry store about 1947, on the south side of SW Capitol Highway. The Al Call's location was later occupied by the Freida Café, and since 1975, it has been the Fat City Café. (Courtesy of the Multnomah Historical Association.)

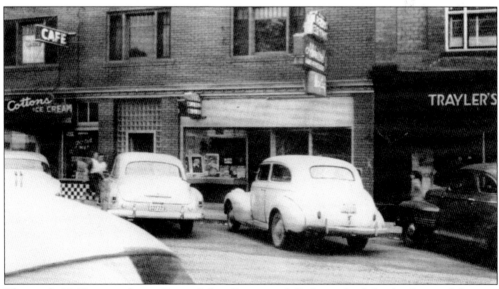

This early-1940s view shows Cotton's Ice Cream and Café on the left, the five and dime in the middle, and Trayler's on the right on SW Capitol Highway. (Courtesy of the Multnomah Historical Association.)

In 1940, the telephone company replaced the telephone prefixes Atwater and Broadway with a new one, Cherry. To house the new telephone exchange, they constructed a brick building in the heart of the Ryan Place residential area of Multnomah. From the front, the building appears to be a rather reserved looking Federal-style residence. From the side, however, its utilitarian nature is clear. The building is now owned by Qwest.

In 1949, William P. (Bill) Borden bought Satterlee's Jewelry in Multnomah and opened Borden's Jewelry. (Courtesy of the Multnomah Historical Association.)

ANNOUNCING

Borden's Jewelry

IN MULTNOMAH

formerly

SATTERLEE'S JEWELRY

Featuring Nationally Advertised
Lines of Merchandise Including

HAMILTON - ELGIN - BULOVA - GRUEN - WYLER
WATCHES and SPEIDEL WATCH BANDS
COMMUNITY and 1847 ROGERS SILVERWARE

Also a Complete Gift Line

We extend to you a cordial invitation to stop in and
get acquainted

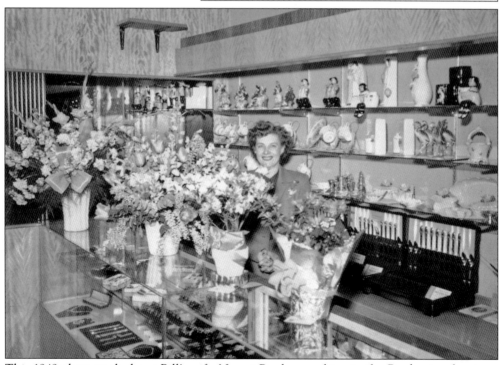

This 1949 photograph shows Bill's wife, Naomi Borden, working in the Borden jewelry store. (Courtesy of the Multnomah Historical Association.)

This June 1966 photograph was probably part of an advertising plan to attract new brides to the Borden store. William P. Borden shows merchandise to an unidentified woman, probably a model. (Courtesy of the Multnomah Historical Association.)

This photograph shows Beatrice Coblentz's second-grade class at Multnomah School in 1948. (Courtesy of Betty Russell Meisner.)

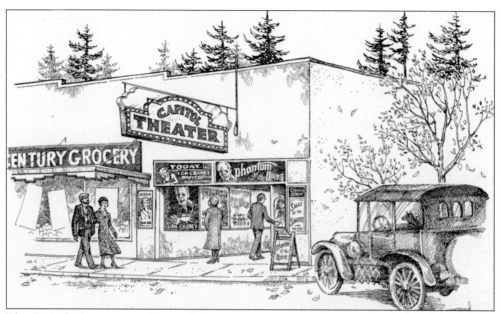

The Capitol Theater opened around 1924 on SW Capitol Highway in a newly constructed L-shaped building on the west side of Beardsley's Garage. The theater suffered a catastrophic fire in January 1930 that destroyed the stage, pipe organ, and six rows of seats. It was rebuilt and reopened as the Multnomah Capitol Theatre in March 1930. The drawing is by Multnomah artist and historical association member Kaye Synoground, who owns and operates the A Closer Look gallery on SW Capitol Highway. (Courtesy of the Multnomah Historical Association.)

In 1944, the theater in Multnomah was purchased by Paul S. Forsythe. It closed for a short while for remodeling and reopened as the Multnomah Theatre on September 15, 1944. The program for the first week was packed with names certain to draw viewers: Mary Martin, Olivia de Haviland, Pat O'Brien, John Wayne, Jean Arthur, and Dorothy Lamour. Not long after it reopened, Forsythe sold the theater to Charles Slaney, manager of Timberline Lodge. (Courtesy of the Multnomah Historical Association.)

Multnomah
THEATRE

Formerly the Capitol
TELEPHONE CH. 9090
MULTNOMAH, OREGON

It's' the Place to Go for the Best
There is in Motion Pictures
Box Office Open Week Days 6:45 P.M.
Sundays and Holidays 1:45 P. M.
Special Kiddie Matinee
Every Saturday 1:45 P. M.

Fri.-Sat., Sept. 15-16—
Franchot Tone — Mary Martin
Dick Powell in
TRUE TO LIFE
and
Pat O'Brien—Ruth Warwick
The Iron Major
Cartoon "Hare Force"

Sun.-Wed., Sept. 17-20—
Olivia De Haviland—Sonny Tufts
GOVERNMENT GIRL
and John Wayne-Jean ‹Arthur
The Lady Takes a Chance
Cartoon and News

Thurs.-Sat., Sept. 21-23—
Dorothy Lamour—Cass Daley in
RIDING HIGH
in Technicolor and
Lum and Abner in
So This is Washington

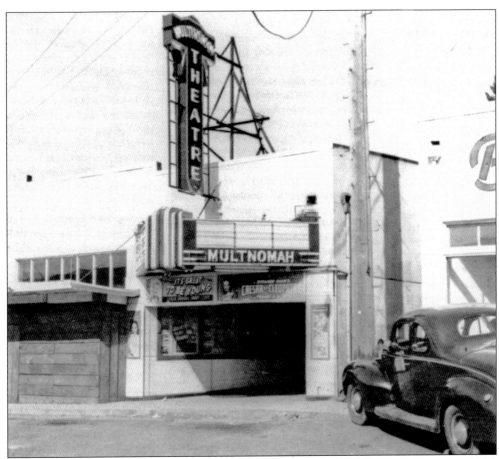

Bill Cate, at one time the projectionist, took this photograph of the Multnomah Theatre in 1946. On the night of June 19, 1949, the theater burned. The fire was reported by Edward W. Schafer, who ran the bakery across the street from the theater; as he was preparing to go to work, he glanced out his apartment window and spotted flames near the chimney. If Schafer had not spotted and reported the flames when he did, the entire block might have burned. As it was, next-door neighbor Tualatin Electric suffered water damage and the loss was nearly $100,000. The theater reopened in 1950, but in April 1954, another devastating fire occurred, and the theater closed for good. Arson was suspected but never proved. The building has been remodeled for business use; the location is currently home to Birdie's Gift Shop and Fibers in Motion. (Courtesy of the Multnomah Historical Association.)

For more than half a century, the Multnomah Days street fair has been a greatly anticipated and much-enjoyed late-summer community event. Dressing up in "old time" period costumes has been a part of the fun from the beginning. Festivities have included parades, street booths, outdoor movies, and more. In 1949, the festivities also included a children's pet parade. This cowboy and little lady are getting ready to parade with their also costumed collie-mix dog. (Courtesy of the Multnomah Historical Association.)

This group of 1949 pet parade participants includes a parade wagon with two kittens inside, a young girl holding a kitten, and a "doctor" and "nurse" accompanied by their dog and cat respectively. In the background are more pet parade wagons, some elaborately decorated. (Courtesy of the Multnomah Historical Association.)

Multnomah Days in the early 1950s called for Native American–themed costumes. In the background can be seen the Multnomah Presbyterian Church. John Feuz of John's Market is the chief standing on the left in this picture. (Courtesy of the Multnomah Historical Association.)

Multnomah storeowners and employees dressed for Chief Multnomah Days in 1954. From left to right are Marge Nary, Charlotte Stricker, Vera Handy, J. or T. Whitcher, and Al Belott. (Courtesy of the Multnomah Historical Association.)

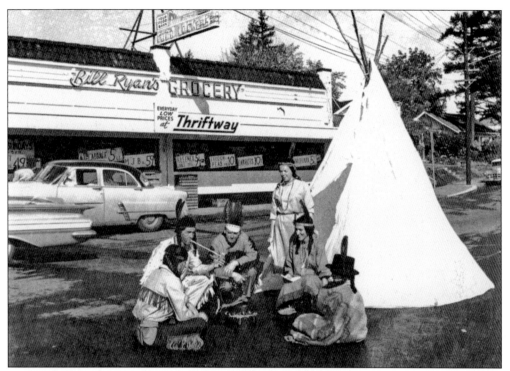

About 1960, employees of Ryan's Grocery celebrated Multnomah Days with Native American costumes and a teepee pitched in the parking lot of the store. (Courtesy of the Multnomah Historical Association.)

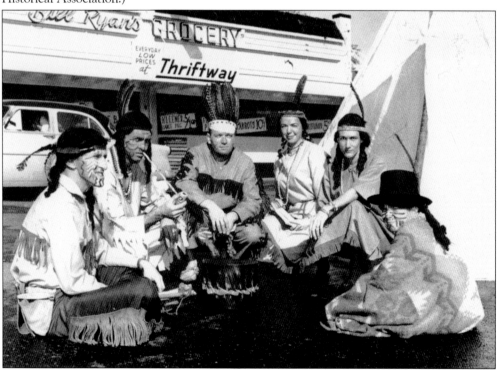

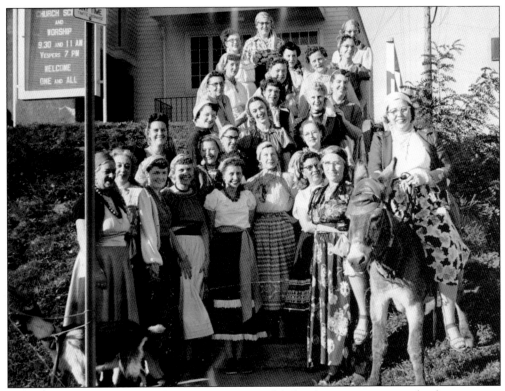

The women of the Multnomah community were delighted to participate in the festivities on Multnomah Days. This picture was taken around 1950 on the steps of the Multnomah United Presbyterian Church. (Courtesy of the Multnomah Historical Association.)

The Multnomah Camp Fire Girls pose on the steps of the Multnomah Presbyterian Church in 1949. The Camp Fire Girl troop was organized in 1936 in Multnomah. (Courtesy of Betty Russell Meisner.)

Costumes were also worn when the school celebrated Centennial Day on February 14, 1959. The Oregon Centennial commemorated the anniversary of Oregon's admission as a state on February 14, 1859. Festivals were held throughout the state, including the Oregon Centennial Exhibition in the Portland neighborhood of Kenton. (Courtesy of Betty Russell Meisner.)

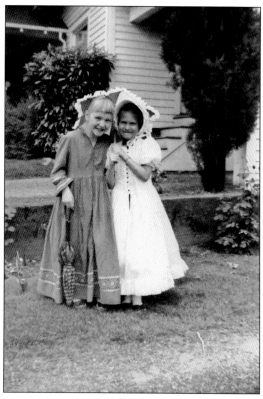

This thermometer was a promotional item for the Multnomah Men's Shop, located on SW Capitol Highway in the space now occupied by the Village Frame Shop. (Courtesy of the Multnomah Historical Association.)

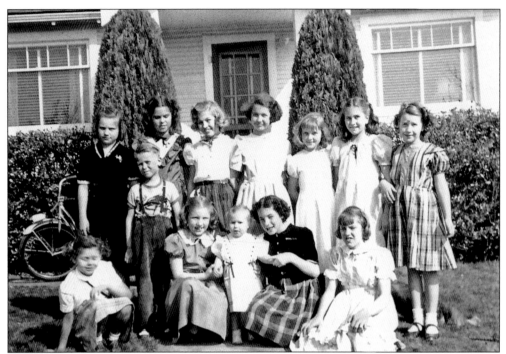

In 1952, children assembled at the Russell house on SW Twenty-seventh Avenue in Multnomah to celebrate Betty Lou Russell's birthday. Pictured are, from left to right, (first row) Karen Holloway, Dennis Russell, Gail Gantenbein, Beverly Russell, Jill Harris, and Linda Gaylord; (second row) Esther Tomlin, Janine Mariels, Carol Sue Gardner, Doris Scott, Elaine Yeager, Betty Lou Russell, and Elaine ?. (Courtesy of Betty Russell Meisner.)

Janine Mariels and Betty Lou Russell enjoy the backyard swing set at the Russell home on SW Twenty-seventh Avenue. (Courtesy of Betty Russell Meisner.)

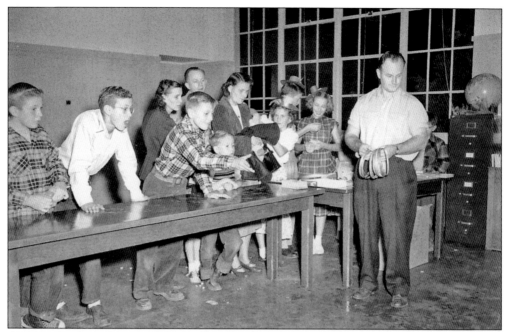

At a carnival evening at Multnomah School in the 1950s, the boys in the foreground are enjoying a ring toss game in a classroom reconfigured for the evening's entertainment. The girls in the background are wearing jaunty party hats adorned with what were likely colorful ribbons. (Courtesy of Betty Russell Meisner.)

Carnivals at Multnomah School included parent participation. In this early 1950 photograph, school dads dress up as women to participate in a comedy skit; the children enjoyed making the costumes that their fathers wore. The elaborately dressed man on the far right wearing an extravagant hat with plume and an oversized, highly decorated shoulder bag is Jess Russell. (Courtesy of Betty Russell Meisner.)

Annie and Henry Tannler are pictured on their farm about 1939, standing where the swings in Gabriel Park are now located. Vermont Street runs behind the apple trees. (Courtesy of the Multnomah Historical Association.)

This 1943 aerial view shows the area that became Gabriel Park. In the lower left of the main photograph, the arched road is the former curved path of the Oregon Electric through the Maplewood neighborhood. The street that runs vertically near the center of the large picture is SW Forty-fifth. The horizontal street just above center is SW Vermont Street. Near the trees along Forty-fifth Avenue, a herd of cows graze. The small picture in the lower right shows the center of Multnomah Village; the curve of the viaduct cuts across the top left corner of this small photograph. (Courtesy of the City of Portland Archives.)

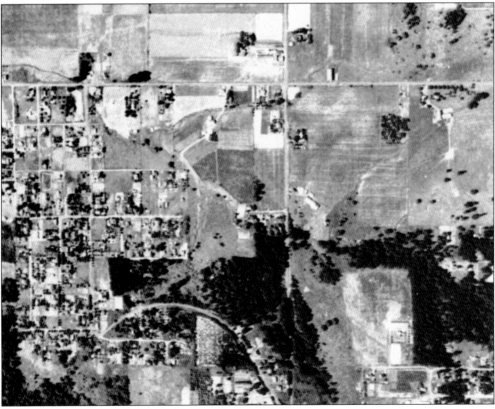

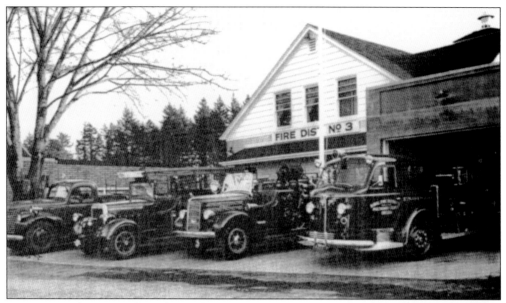

In 1939, a fire district was formed in Multnomah. The station was built at 7780 SW Capitol Highway in 1939–1940 and much of its equipment, parked here in front of the station, was obtained. On the first floor, the station had an office, engine room, two sleeping rooms, and a bathroom with a shower. The finished attic contained four sleeping rooms, and the basement had a kitchen, recreation room, bathroom, and furnace room. The fire district's formation was a project of the Community Club, which was organized in 1938. It elected Martin Welch as its first president. (Courtesy of the Multnomah Historical Association.)

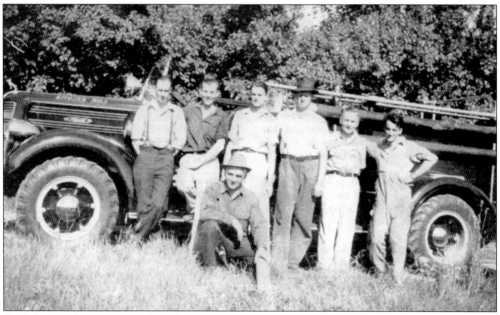

On July 23, 1939, Multnomah volunteer firemen line up for a photograph in front of their first apparatus. From left to right are (first row) William Surplice (chief of the Multnomah Volunteer Fire Department); (second row) Ken Twombly, Bryan Emerson, Harold Gellatly, unidentified, Maurice Hart, and Al Schmitz. (Courtesy of the Multnomah Historical Association.)

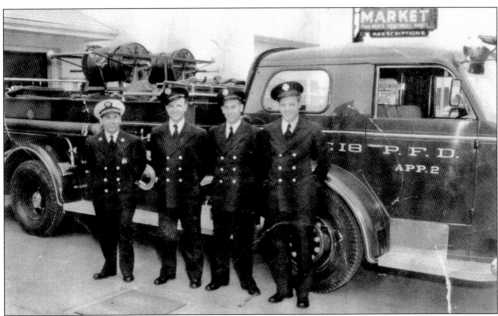

Multnomah, which continued to grow, was eventually annexed to Portland over an eight-year period beginning in 1954. In this 1954 photograph, (from left to right) Arno O'Dell (the shortest man in the Portland Fire Bureau at 5 feet, 3 inches), Merrill Carter, Ronald Redman, and Philip Peer stand before Station 18's newest apparatus—a 1947 American LaFrance fire engine that cost approximately $18,000. O'Dell had been a captain in the district department and, after Multnomah was annexed, came into the Portland Fire Bureau (PFB) as a lieutenant. He was grandfathered in for his height, as 5 feet, 7 inches was the PFB standard of the day. (Courtesy of the Portland Fire and Rescue Archives.)

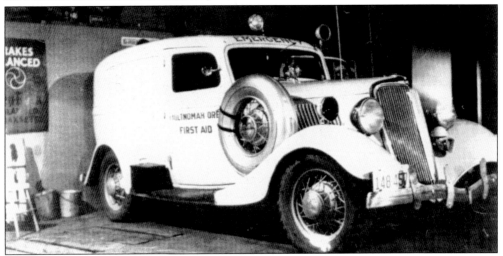

Pictured here is Multnomah's earliest first aid car. During World War II, a complete Casualty Unit, under the direction of Dr. Ira Manville, was trained and maintained. It included first aid and nursing units as well as a canteen. Ready for any disaster, large or small, it is fortunate that it was never called into action. Its setup was so well done that it served as a model for similar organizations elsewhere. The first aid car was the forerunner of the Tualatin Valley ambulance. (Courtesy of the Multnomah Historical Association.)

Multnomah was a perfect neighborhood for Clipper Matusek to roam on his tractor-trike in the early 1950s. In the background is SW Twenty-seventh Avenue. (Courtesy of Betty Russell Meisner.)

Snow, then as now, was a relatively uncommon occurrence in this temperate location. Here Shirley Eichman and Betty Lou Russell share a sled on SW Twenty-seventh Avenue in the 1950s. (Courtesy of Betty Russell Meisner.)

Dwight E. Gard, pictured here in his officer's uniform about 1941, was a World War II veteran and the driving force behind the organization of the new Multnomah Bank in 1948. Working with the community leaders in Multnomah, including Werner Raz (who had been a principal in the Multnomah Commercial and Savings Bank), he obtained a charter for the bank in 1948. (Courtesy of the Multnomah Historical Association.)

In early 1949, the new Multnomah Bank opened in the space formerly occupied by the Multnomah Commercial and Savings Bank on SW Capitol Highway. It occupied this space while a new building was designed and constructed. After the bank moved, the building was used by several storefront businesses, including Laurie and Casey's Antiques. It is now part of O'Connor's Restaurant. (Courtesy of the Multnomah Historical Association.)

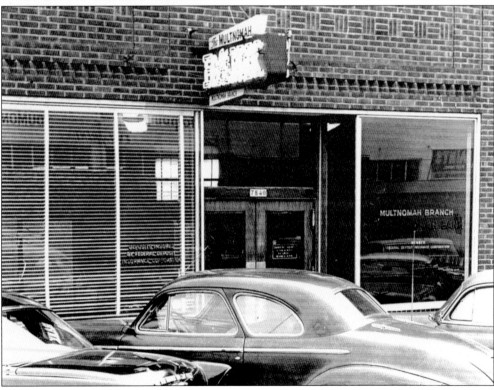

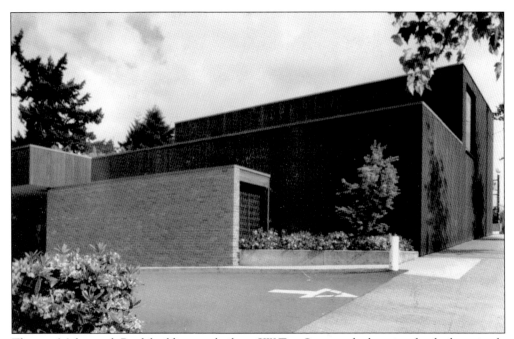

The new Multnomah Bank building was built on SW Troy Street at the location that had previously been the Multnomah Presbyterian Church. Over time, it established additional branches on Barbur Boulevard, in Hillsdale, and in Progress. (Courtesy of the Multnomah Historical Association.)

This bust of Multnomah, the great chief, is a small coin bank, approximately 4 inches tall, that the Multnomah Bank distributed to children in the 1950s to encourage them to save money. Multnomah, for whom Multnomah Village is named, was chief of the Willamette Indians and ruler of the Confederated Tribes in 1817. The Confederated Tribes included all the tribes of Oregon Country, from the Rogue River Indians and Klamaths in the south; to the Blackfoot and Shoshone in the east; the Colvilles and Flatheads in the north; and the Quinsoults, Cowlitz, Tillamooks, and Siletz tribes in the west. By 1836, when the earliest white settlers began to arrive, the Native American population of Oregon was decimated by exposure to new diseases, especially smallpox. (Courtesy of Betty Russell Meisner.)

In November 1970, the Multnomah Bank became part of the First State Bank, which was later acquired by Key Bank. The branch is still in operation. (Courtesy of the Multnomah Historical Association.)

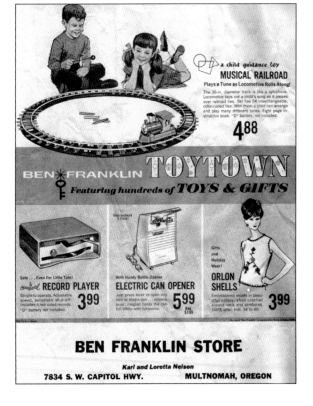

This 1950s-era flyer was from Multnomah's Ben Franklin Store, operated by Karl and Loretta Nelson. The store preceded the Multnomah Rexall drugstore. This storefront is now Annie Bloom's Bookstore, which has been at this location since 1978. (Courtesy of Jim and Kathy Hill.)

The Fat City Café in Multnomah made front page news in April 1987 when Portland's mayor, Bud Clark, met with police chief Jim Davis for breakfast there—and ended up firing him on the spot. Clark did not think the police chief had the authority to take legal action to obtain the files used to prepare a police audit, and Davis vehemently disagreed. Their exchange of words reportedly was: Davis: "Yes, I do. Read my lips." Clark: "Read my lips. You're fired. Goodbye."

Stocks
Market drops 44.60; closes at 2,360.94
— Page B5

The Oregonian

VOL. 136 — No. 45,070 SUNRISE EDITION PORTLAND, OREGON, WEDNESDAY, APRIL 8, 1987 68 PAGES 25 CENTS

Mayor fires Police Chief Davis
Ex-deputy chief moved from City Hall to take over

By DEE LANE
and TOM HALLMAN
Of The Oregonian staff

Mayor Bud Clark fired Portland Police Chief James T. Davis Tuesday morning and quickly replaced him with Richard D. Walker, executive assistant to Commissioner Dick Bogle and a former deputy police chief.

Davis, who was demoted to captain, said it was impossible to be police chief under Clark and immediately announced he would run for mayor in 1988.

Their dispute centered on an audit of the Police Bureau, but Davis

■ The Police Bureau's claim that it is understaffed and needs 30 additional positions is "not adequately supported," according to an audit that helped lead to the firing of the chief. Page C2

said Clark's proposed city budget was the underlying source of disagreement between the two men.

"I think I've got another disappointment on my hands," Clark said of the departure of Davis less than a year after the resignation of former Chief Penny Harrington.

Clark has defended his budget proposal — to shift more police to patrol duties without hiring new officers — as a way to increase police protection without forcing a tax increase or more cuts in other bureaus.

The mayor appeared calm at a packed morning news conference as he read a statement he had written and typed himself moments before. He joked that if Davis ran for mayor, he would have to ask Clark for a leave of absence from the Police Bureau to campaign.

The announcement of the appointment of Walker as chief drew a standing ovation from City Hall employees assembled in the council chambers, including loud applause from the front row bench, jammed with members of Bogle's staff. Walker joked that most of the applause was from Bogle's staff because Walker would no longer be their boss.

Walker, 60, said he thought he knew about two weeks of tension between the mayor and the police chief over the proposed police budget and a performance audit of the police patrol function.

The breaking point came Monday when Davis sent a memo to the audi-

Walker was sworn in at a 5 p.m. ceremony at City Hall, because he served as interim chief when Clark took office, he was the first and fifth police chief of Clark's mayoral term.

Clark aide Charles P. Duffy reacted angrily to Davis' statement that it was impossible to be a good chief under Clark. "The chief is just flat-out wrong, and that's all there is to that," Duffy said.

The action Tuesday morning followed about two weeks of tension between the mayor and the police chief over the proposed police budget and a performance audit of the police patrol function.

The breaking point came Monday when Davis sent a memo to the audi-

tor's office requesting copies of certain working papers and threatened to sue the city if the request wasn't met, according to Davis and Clark.

Clark told the chief to back down, but Tuesday morning, during breakfast at Fat City, a Multnomah neighborhood cafe, Davis refused to back down. Clark fired him.

"Because of the chief's refusal, I had no choice but to relieve him of his duties," Clark said.

The mayor said Davis had threatened to resign two weeks ago when he was told there would be no money in the new budget proposal for additional police. Davis requested 30 more officers each year for four years.

Davis said the budget was the underlying problem, and the audit was just the "straw that broke the camel's back."

He said Clark's proposed budget, described by Clark as a "public safety budget," was the real problem.

"If he was interested in public safety, he would have done something to rectify it," Davis said. "If they want the lawns mowed in the park, fine; but no one will feel safe enough to go to the park."

At $48.5 million, the Police Bureau budget is the largest general fund budget in city government, and it received fewer cuts in the budget process than other city bureaus.

Clark based his budget decisions in part on a draft copy of the patrol audit, which city Auditor Barbara Clark said he received March 25.

"From the time that this was on the schedule, Chief Davis didn't seem to like it," Barbara Clark said. "Before we had conclusions, he didn't like the questions. He felt that it was a waste of time for us to examine questions that had already been examined by police management. The idea that we would have anything new to offer was ridiculous to him."

Davis contended he needed the audit documents to prepare to lobby city commissioners to restore money.

Mayor Bud Clark and new Police Chief Richard D. Walker speak at a news conference Tuesday. The Oregonian/MICHAEL LLOYD

Charles P. Duffy, an aide to Clark, said the mayor gave this description of an exchange in the Fat City cafe between Clark and Davis after Clark said he didn't think the police chief had authority to take legal action to get files used to prepare a Police Bureau audit:

DAVIS: "Yes I do. Read my lips."

CLARK: "Read my lips: Goodbye."

JAMES T. DAVIS
Declares his candidacy

The Fat City firing

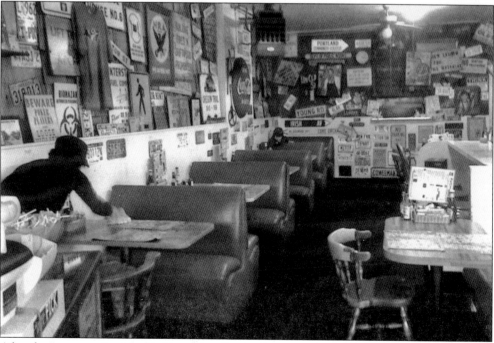

After the "massacre," quick-thinking owner Louise Boyer augmented the café's eclectic collection of road signs by placing a new one above the booth where the men had been sitting. It reads: Fat City Massacre Lip Reading Done Here.

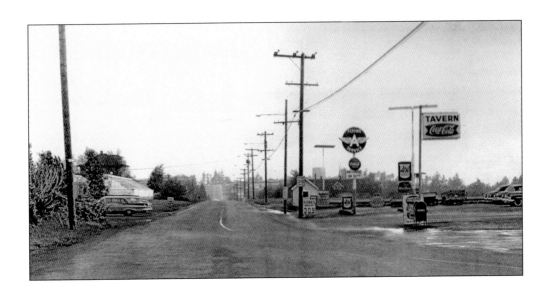

Multnomah retained its semirural air for many years, as evidenced by these 1963 photographs looking east on SW Capitol Highway from a point approximately 20 feet east of the east line of SW Thirtieth Avenue. In the first photograph, the building on the right is the area now occupied by the Hoot Owl and the Cider Mill restaurant. (Courtesy of the City of Portland Archives.)

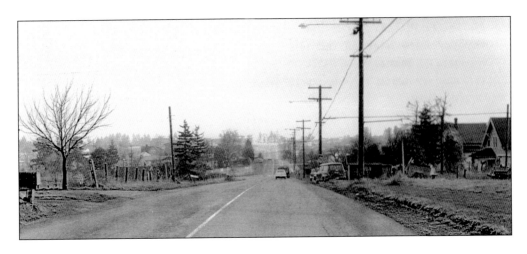

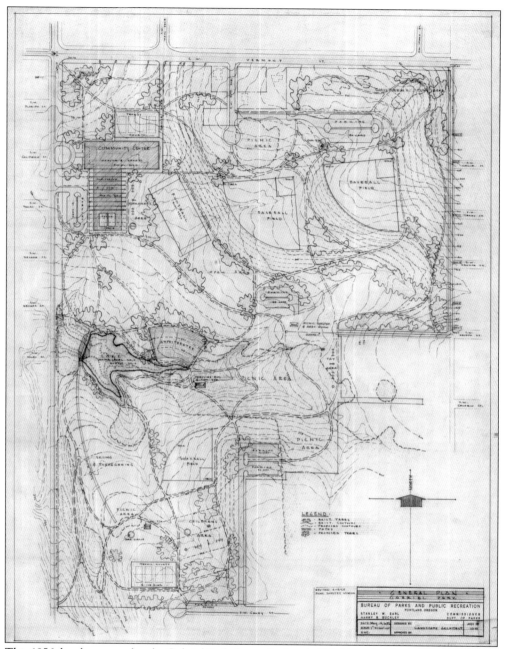

This 1956 development plan for Gabriel Park shows the baseball fields, a sledding and tobogganing hill, tennis courts, an ice rink, picnic areas, and small lakes. The park has not been developed strictly according to this plan; however, it captures the vision for the space that inspired the former owners to sell the property to the city so that it could be developed for public use. (Courtesy of the City of Portland Archives.)

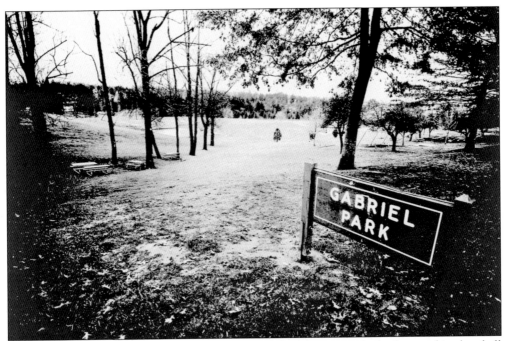

This view of Gabriel Park was taken in 1974. To the left of the sign in the background is a baseball diamond, and in the left foreground are picnic tables. On the right, swing sets are placed under the trees for shade. (Courtesy of the City of Portland Archives.)

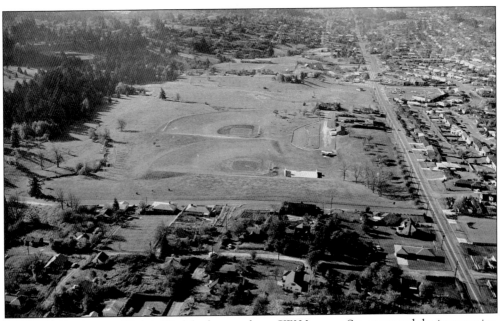

This 1964 aerial view of Gabriel Park looks west down SW Vermont Street toward the intersection with SW Forty-fifth Avenue. In the foreground, SW Thirty-seventh Avenue borders the green space. Gabriel Park is named for the Gabriel family. Margaret Gabriel, John and Anna Gabriel Feuz, and Mrs. Henry Tannler sold adjacent tracts of land to the city of Portland to develop as a park. (Courtesy of the City of Portland Archives.)

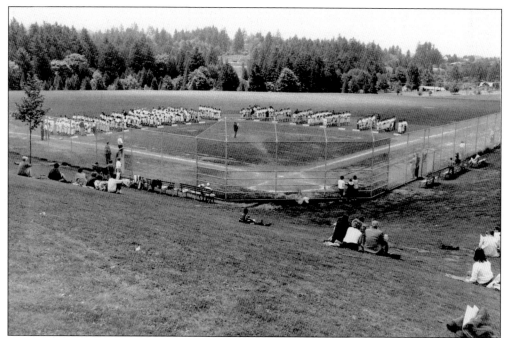

The opening ceremony for Gabriel Park was held on the baseball field in 1954. (Courtesy of the City of Portland Archives.)

The hills in Gabriel Park were a popular, dark site for star viewing in southwest Portland. In the 1980s and 1990s, Oregon Museum of Science and Industry and Rose City astronomers, along with amateur observers, used the site regularly during the summer for star parties. In the 1990s, the park was a favorite observation site for viewing the Shoemaker Levy 9 impact of Jupiter and the Halle Bopp and Hykatake comets. This view shows, from left to right, David Tevr, Dennis Anderson, and Robert (Bob) McGown setting up several types of telescopes at the site. Other regular observers included Peter Abrahms, Kendall Auel, John Buting, Gary and Cecile Beyl, John Dobson, Carol Huston, Jan Keiski, Russ Paul, Candice Pratt, and Stan Seeberg.

The pump station seen in the landscaping plan was installed in 1966 near the intersection of SW Forty-fifth Avenue and SW Vermont Street. (Courtesy of the City of Portland Archives.)

This 1966 view shows SW Vermont Street from the intersection of SW Forty-fifth Avenue. (Courtesy of the City of Portland Archives.)

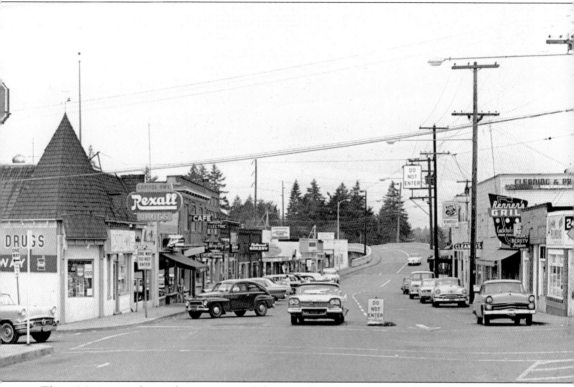

This 1964 image shows the commercial district of Multnomah. While there are superficial differences, familiar structures are in place. Capitol Highway Drugs has replaced the Ellis Pharmacy, and John's Market has moved down the hill and an apparel store occupies its former location. Two-way traffic has been altered to one-way traffic on this two-block stretch of Capitol Highway, with westbound traffic being routed along SW Troy Street. On the left, the storefronts include the Capitol Highway drugstore, the Multnomah Men's Shop, an apparel shop, a café and ice cream store, a radio-electric appliance store, Ed's Camera Corner, Multnomah Bakery, Multnomah Tavern, Coast-to-Coast Hardware, a dry cleaning business, and the Christian Science reading room. On the right, the burned-out ticket booth of the Multnomah Theatre is visible beyond Beardsley Auto Parts, which succeeded Beardsley's Garage. The Multnomah Cleaners and Ada's Beauty Salon flank Renner's Grill. The "flatiron" building on the corner of Troy Street and Thirty-fifth Avenue is home to a plumbing store. (Courtesy of the Multnomah Historical Association.)

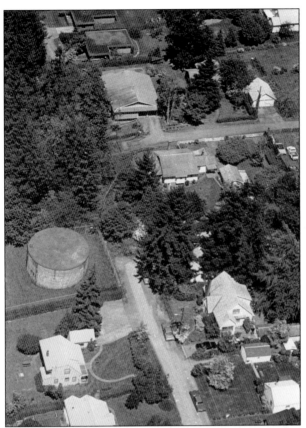

This 1980 view shows the Freeman water tank at 8625 SW Forty-second Avenue from the air. The street to the right of the tank is SW Forty-second; the street that dead-ends into the treed area is SW Freeman. The area is part of the Primrose Addition. (Courtesy of the City of Portland Archives.)

This photograph of the water tank on SW Texas Street was taken in May 1980 looking north. SW Texas Street is to the left of the tower property. SW Nevada Street, to the right of the tower, is now closed to automobile traffic. In 1980, the mature cedar and fir trees that now surround the tank were still immature. The church in the upper left of the photograph is the Hillsdale Community Church, erected in 1966. It occupies a site purchased about 1918 by Henry Raz, where he built (with the help of his brothers) a frame church and parsonage. (Courtesy of the City of Portland Archives.)

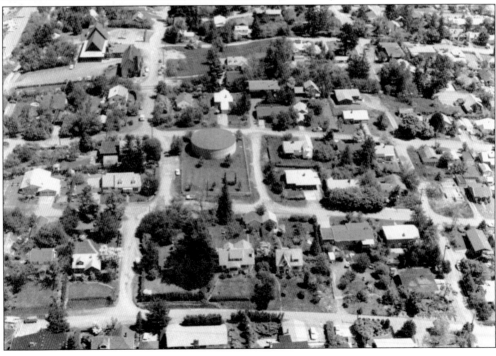

This view of Custer Park from SW Miles Street was taken in 1963. Both Custer Street and Custer Park are named for Gen. George Armstrong Custer, a U.S. Calvary officer and Civil War veteran killed in 1876 at age 36 in a poorly chosen battle with the Sioux Indians at Little Big Horn in Montana. He enjoyed considerable national prominence at the time of his death. (Courtesy of the City of Portland Archives.)

This image shows the view of Custer Park from the intersection of SW Miles Street and SW Capitol Hill Road on June 20, 1975. Capitol Hill is a small hill in southwest Portland on which residential property with a view was developed beginning in 1907. (Courtesy of the City of Portland Archives.)

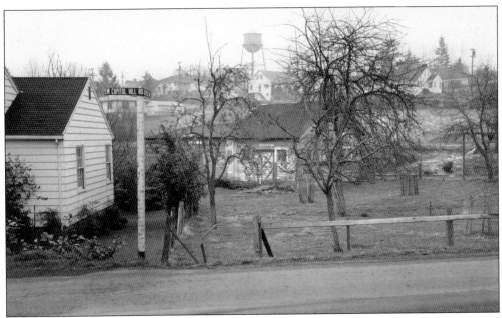

In this 1963 view looking from SW Miles Street toward Capitol Hill, the SW Canby Street water tower can be seen in the background. Canby Street is named for Gen. Edward Richard Sprigg Canby (1817–1873), a career U.S. Army officer and veteran of the Civil War and Indian Wars. In 1873, he was killed near Klamath Falls in southern Oregon while attempting to resolve a dispute between the U.S. government and the Modoc Indians. Canby, who was sympathetic to the Modoc cause, was assigned to mediate and was tragically murdered as a result of convoluted communication and frustrating parleys between the Native Americans and whites. Despite Canby's hope for honorable peace and fair treatment for the Native Americans, his death triggered a severe backlash against them, especially the Modoc. (Courtesy of the City of Portland Archives.)

This photograph of SW Miles Street in 1961 shows how the unpaved streets and open spaces around the area gave the place a rural feel, even though it was close to the city of Portland. (Courtesy of the City of Portland Archives.)

In 1961, sewer lines were installed in the eastern parts of Multnomah. This view shows the preparations for installation on SW Miles Street. A curious standard poodle inspects the scene. (Courtesy of the City of Portland Archives.)

This 1961 view looks east down SW Miles Street. The unpaved streets continued to give Multnomah a rural feel even though the neighborhood was annexed by Portland years earlier. The Rutis house is at the end of the street. (Courtesy of the City of Portland Archives.)

This 1961 view looks west along SW Miles Street. (Courtesy of the City of Portland Archives.)

In 1961, John Rutis, owner of the home at the end of SW Miles Street, inspects the sewer pipes laid out in preparation for installation. (Courtesy of the City of Portland Archives.)

This 1961 view shows the intersection of SW Miles Street and SW Capitol Hill Road. The Rutis home is in the center background. (Courtesy of the City of Portland Archives.)

Another 1961 view shows the intersection of SW Thirty-fourth Avenue and SW Canby Street. (Courtesy of the City of Portland Archives.)

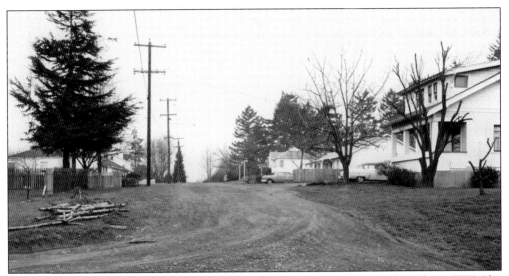

This February 1963 image shows the view from SW Twenty-fifth Avenue looking down SW Miles Street. (Courtesy of the City of Portland Archives.)

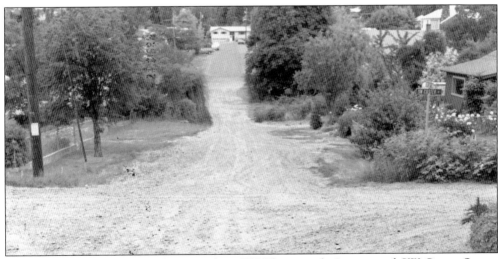

In 1976, this was the view looking north at SW Thirty-sixth Avenue and SW Custer Street. (Courtesy of the City of Portland Archives.)

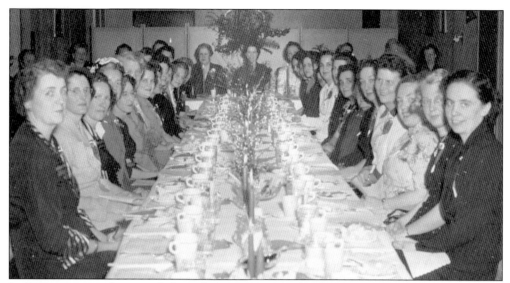

In 1927, women predominantly from the Multnomah and Hillsdale area formed the 36 Club. The club's purpose was to promote and support a variety of community service activities. The women met monthly at one of the member's homes to enjoy a potluck lunch and discuss and plan club projects and activities. In 1952, the 36 Club celebrated its 25th anniversary at the Multnomah Christian Church. (Courtesy of Betty Russell Meisner.)

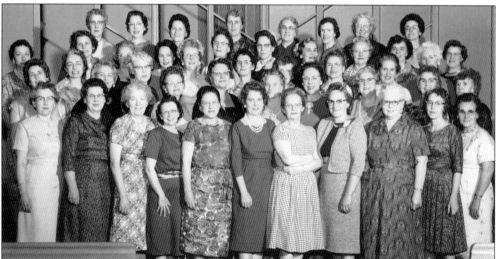

In 1962, the 36 Club celebrated its 35th anniversary at the Multnomah Presbyterian Church. From left to right are (first row) Helen Clow, Evelyn Beckendorf, Henrietta Raz Fahner, Elizabeth Watson, Eileen Raz, Opal Brissenden, Bernice Hodges Brust, Helen Friedli Irish, Verlie Hodges Joley, Vera Withington, and Anna Lehrer; (second row) June Panko, Ruth Doescher Simpson, Lyla Scott Gardner, Dorothy Young, Clara Hathaway, Betty Weitzel Veley, Adeline Priest, LaVerne Carr, Hazel N. Loomis, Alice Gaylord Weeks, and Anna Hirsch; (third row) Margarete Raz, Selma Raz, Mary Brissenden Green, Bessie Rifer, Louise Kinzey, Victoria Girton, Margaret Hughes, Lois Pomeroy, Ruth Pearson Magedanz, Alma Hagey Quinn, Merle Bartnik, Lena Abplanalp, Norma Gaylord, Mathilda Raz, Afton Sandstrom, and Myra Atkeson; (fourth row) Eleanor Cobb, Irma Nagel Lee, Ruth Russell, Lola Voit Raz, Ethel Speakman Manning, Mary Nimmo, Esther Raz Tolle, and Alice Malin Cochran. (Courtesy of Betty Russell Meisner.)

The 36 Club celebrated its 45th anniversary in 1972 at the Multnomah Presbyterian Church on SW Forty-fifth Avenue. From left to right are (first row) Bessie Pancake, Elizabeth Watson, Alma Hagey Quinn, Helen Friedli Irish, Norma Gaylord, Merle Bartnik (seated), LaVerne Carr, Helen Stewart Hays, Ethel Speakman Manning, and Ruth Doescher Simpson; (second row) Marguerite Sowles, Rosa Schild, Mathilda Raz, Bessie Rifer, Mary Brissenden Green, Helen Clow Robinson, and Dorothy Raz; (third row) Lyla Scott Gardner, Ruth Pearson Magedanz, Eileen Goode Raz, and Lois Scott Pomeroy, Selma Raz, Lena Alplanalp Stoneroad, Anna Lehrer, Mary Nimmo, and Esther Raz Tolls; (fourth row) Marguerite Raz, Louise Bracken Kimzey, Lola Voit Raz, Irma Nagel Lee, Doris Dickhart, Opal Brissenden, and Ruth Russell. (Courtesy of Betty Russell Meisner.)

Dick's Second Hand Emporium opened in the 1970s and was located on the southeast corner of the intersection between SW Capitol Highway and SW Thirty-sixth Avenue. This photograph of the owner and store was taken around 1985. (Courtesy of Jim and Kathy Hill.)

Six

THEN AND NOW

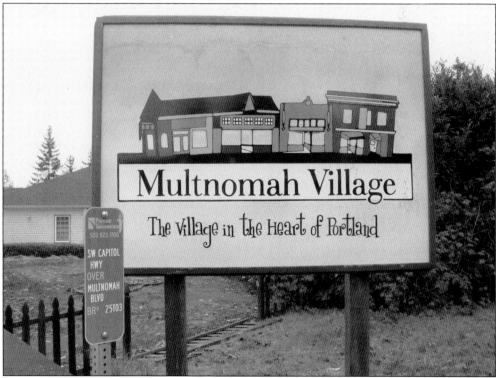

On maps before 1908, the area now known as Multnomah Village is generally labeled as the "Home Addition," the name given to a section of streets now bounded by SW Hume Street, SW Thirty-sixth Avenue, SW Canby Street, and SW Thirty-seventh Avenue. Beginning when the Oregon Electric Railroad established their Multnomah station here in 1908, the area generally was referred to as "Multnomah Station." When the trains stopped running in 1933, the tracks removed, and the former rail bed paved over for automobile traffic, most residents simply referred to the neighborhood as Multnomah. It is now most often called Multnomah Village, the usage found on signs on SW Capitol Highway as people enter the area. This one is located at the eastern side of the viaduct that crosses SW Multnomah Boulevard.

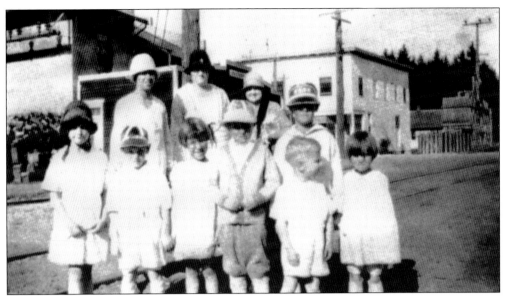

This 1927 image shows a group gathered in front of the railroad station at Multnomah. In the background is the Nelson Thomas building. From left to right are (first row) Dores Johnson Van Bishler, Bobby Amos, Virginia Johnson Fredrickson, and four unidentified; (second row) unidentified, Adeline C. Amos, and unidentified. (Courtesy of the Multnomah Historical Association.)

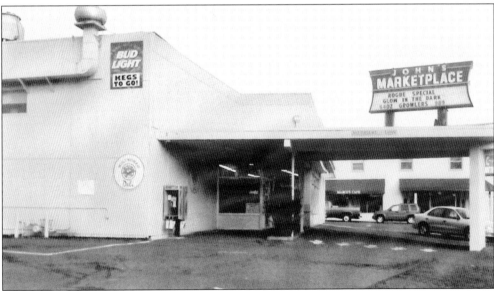

The depot building was remodeled in 1957; John's Marketplace now occupies the location. In the background is the Nelson Thomas building. Macro's Restaurant is located on the first floor. The upper floors are now mainly used as office space. In the past, the upper floors of the building served as meeting space, particularly before the Multnomah Community Church was built in the 1920s. It served more colorful purposes as well, being used for a time as a brothel and as a finishing school (perhaps both at the same time).

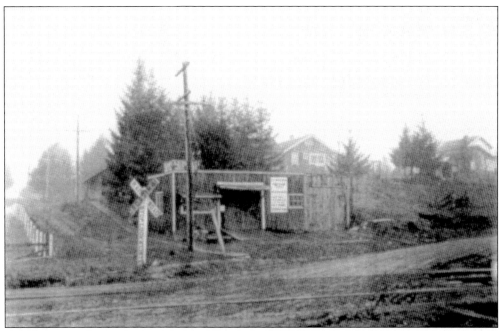

Accidents at this railway crossing, presently SW Thirty-seventh Avenue and Capitol Highway, led to the construction of a concrete overpass in 1927. (Courtesy of the Multnomah Historical Association.)

The Multnomah Overpass, most often called the viaduct by locals, carries Capitol Highway over Multnomah Boulevard. This view is from the foot of SW Thirty-fourth Avenue looking west.

Daniel M. Florea, with permission of the building owners, created a 400-foot-wide by 25-foot-tall mural on the west side of SW Thirty-fifth Avenue between SW Multnomah Boulevard and SW Capitol Highway. City commissioner Mildred Schwab dedicated the mural during the annual Multnomah Days celebration in 1986. The image was featured in the *Oregonian* on August 26, 1986.

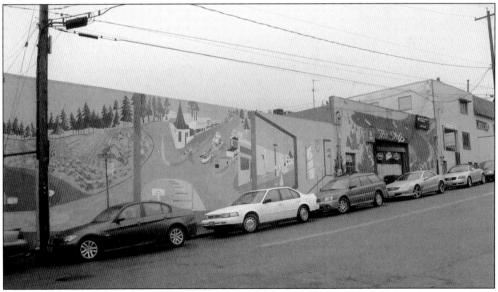

The best vantage point for viewing the mural is from the corner of SW Moss Street and SW Thirty-fifth Avenue. This picture was taken looking northwest. The building on the left is John's Marketplace, the Ship Tavern is to the right, and the Acapulco Gold Southwest restaurant is on the far right.

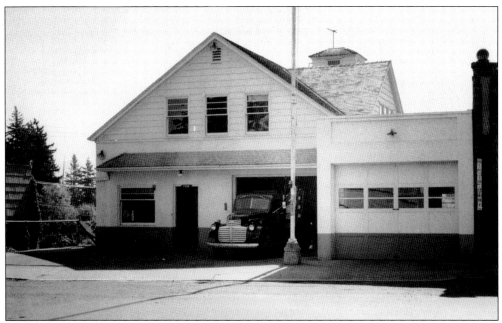

This view of Fire Station 18 in Multnomah Village at 7780 SW Capitol Highway was taken in 1951. With the annexation of Multnomah by the city of Portland, the operation of the station switched from volunteers to being supported by the city's Portland Fire and Rescue Bureau. In 1954, an adjacent building behind this fire station, at 3445 SW Moss Street, was remodeled for use as a police station. (Courtesy of the Portland Fire and Rescue archives.)

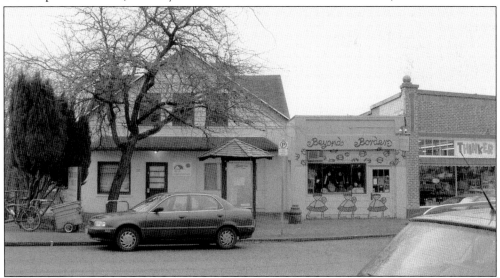

The old fire station is now the headquarters of Neighborhood House. Until Neighborhood House expanded to include this space, the garage was home to the shop Beyond Borders (formerly Catfish Moon in Hillsdale). Neighborhood House, founded in January 1905, settled into the Multnomah neighborhood in 1982. The organization grew out of the Sewing Circle for girls in South Portland, founded in 1896 by the Portland Chapter of the National Council for Jewish Women. It is now the primary organization providing social and support services for families in southwest Portland.

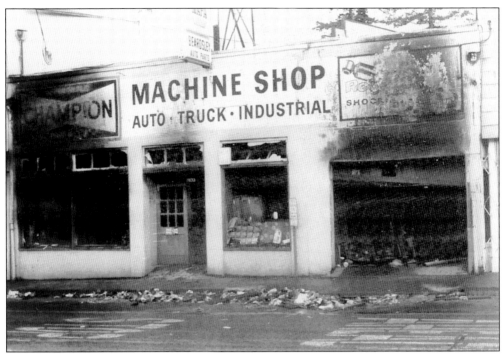

The Beardsley Machine Shop and Auto Parts store suffered a fire in 1977 that caused significant damage to the building and roof. (Courtesy of the Multnomah Historical Association.)

The building was eventually torn down. It now stands empty and is used for parking by the owner. A new building is planned for the location. Multnomah merchants and residents are keenly interested in the development planned for the location.

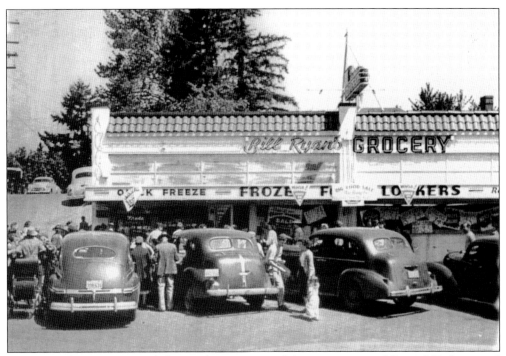

Bill Ryan's Grocery occupied the northeast corner of the intersection of Capitol Highway and SW Thirty-fifth Avenue in the 1920s. (Courtesy of the Multnomah Historical Association.)

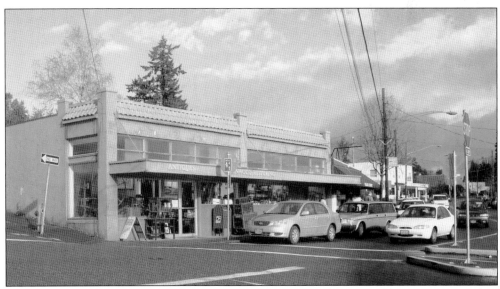

Today the northeast corner is home to Pagenwood Restoration shop, owned by Tom Pagenstecher, which has occupied the space since 1976.

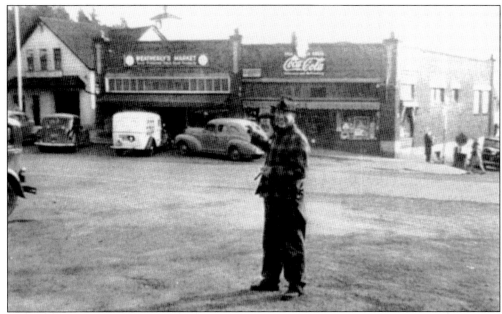

This view of the southeast corner of the intersection of Capitol Highway and SW Thirty-fifth Avenue was taken about 1940. Pictured from left to right are the fire station, Weatherly's Grocery Store, and the Multnomah Drugstore. Rev. Henry E. Moore, pastor of the Multnomah Community Church from 1929 to 1946, stands in the foreground. (Courtesy of the Multnomah Historical Association.)

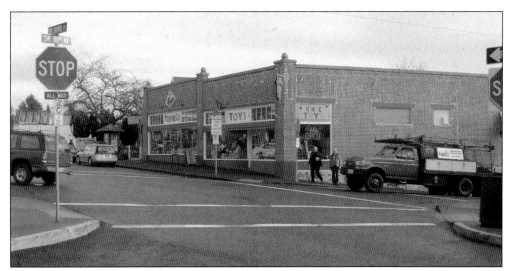

In 2006, the buildings on the southeast corner of the intersection of Capitol Highway and SW Thirty-fifth Avenue are home to a toy store. Thinker Toys now occupies the buildings that were once Weatherly's Grocery and the Multnomah Drugstore. Before Thinker Toys, the building was home to the Multnomah Antique Mall for several years.

In 1961, the Texas Street water tank was strictly utilitarian and surrounded by a chain link fence to deter vandalism and trespassing. (Courtesy of the City of Portland Archives.)

In 2006, the .39 acres of land occupied by the Texas Street water tank was reconfigured as a hydro park, the first in the city of Portland. It opened on October 8, 2006. This view shows the neighbors pitching in shortly before the opening to plant flowers, shrubs, and trees and otherwise improve the appearance of the park. The water tank, in the background, was painted by the city to improve its appearance. (Courtesy of the Portland Bureau of Water Works.)

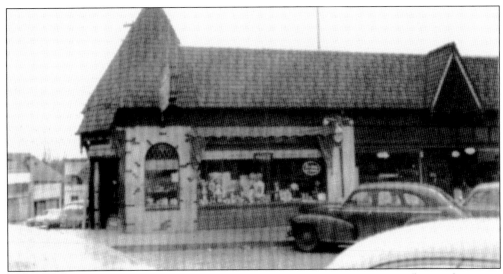

In 1927, the Ellis Pharmacy moved into its new building with the distinctive roofline at the corner of SW Capitol Highway and SW Thirty-fifth Avenue. The Nelson Thomas building can be seen in the left background of the photograph, at the bottom of SW Thirty-fifth Avenue. (Courtesy of the Multnomah Historical Association.)

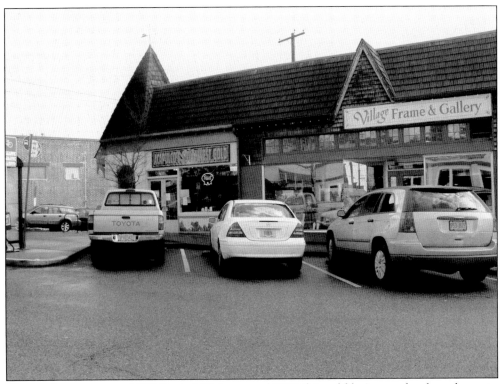

The southwest corner of SW Capitol Highway and SW Thirty-fifth Avenue has been home to Acapulco Gold Southwest since 1984. The restaurant retains the counter and stools from the building's drugstore days. The space next door is now home to the Village Frame and Gallery Shop.

Previous occupants of this storefront include longtime Multnomah antique shop J K Hills Antiques, operated by Jim and Kathy Hill. This was the shop's third Multnomah location. (Courtesy of Jim and Kathy Hill.)

The northwest corner of SW Thirty-fifth Avenue and SW Capitol Highway for many years featured stairs used to ascend the hill, which can be seen at left in this c. 1996 image. The stairs have since been replaced with a ramp. (Courtesy of Jim and Kathy Hill.)

About 1990, Auntie's Attic antique store occupied the triangular space created by the oblique intersection of SW Troy Street and SW Capitol Highway. (Courtesy of the Multnomah Historical Association.)

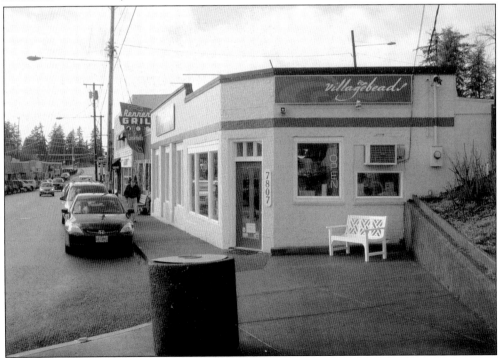

In 2006, Village Beads owned by Michelle Cassinelli moved in to the corner building from another location farther east on Capitol Highway.

Renner's Grill has been a fixture in Multnomah since 1939. This photograph was taken in September 1986 and appeared in the *Oregonian*. (Courtesy of the Multnomah Historical Association.)

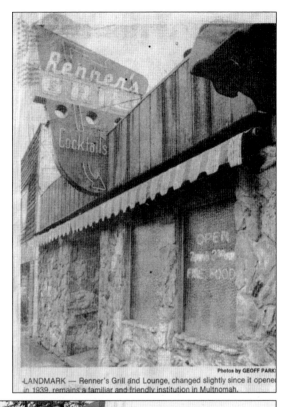

Photos by GEOFF PARK

LANDMARK — Renner's Grill and Lounge, changed slightly since it opened in 1939, remains a familiar and friendly institution in Multnomah.

Today Renner's continues, little changed from 1939, at least on the outside. The inside is decorated with photographs and memorabilia and is especially popular among longtime residents. Village Beads can be seen on the right.

Index